IMAGES
of America

TARRYTOWN AND SLEEPY HOLLOW

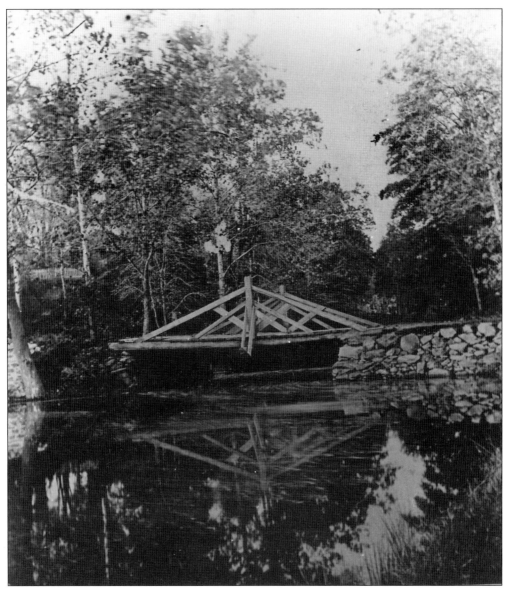

The famed "Headless Horseman" bridge over the Pocantico River as Washington Irving would have seen it.

IMAGES
of America

TARRYTOWN AND
SLEEPY HOLLOW

The Historical Society, Inc.
Serving Sleepy Hollow and Tarrytown

ARCADIA
PUBLISHING

Published by Arcadia Publishing
Charleston SC, Chicago IL, Portsmouth NH, San Francisco CA

Printed in the United States of America

Library of Congress Catalog Card Number: 2008922478

For all general information contact Arcadia Publishing at:
Telephone 843-853-2070
Fax 843-853-0044
E-mail sales@arcadiapublishing.com
For customer service and orders:
Toll-Free 1-888-313-2665

Visit us on the Internet at www.arcadiapublishing.com

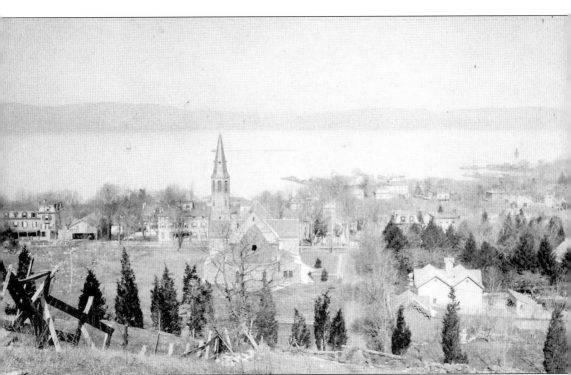

A view of Tarrytown and the Hudson River from Grove Street, *c.* 1896.

Contents

Acknowledgments 6

Introduction 7

1. Beginnings 9

2. The Capture 15

3. The Homefront 19

4. Village Scenes 27

5. Houses on the Hudson 39

6. Working Men and Women 53

7. School Days 71

8. The River 85

9. Trains 95

10. Volunteer Firemen 99

11. Religious Life 107

12. The People 117

Acknowledgments

The authors would like to thank the people of Tarrytown and Sleepy Hollow for the donations of their precious photographs and postcards to the Historical Society's photograph collection.

The archives of the Historical Society, the *History of the Tarrytowns* by Jeff Canning and Wally Buxton, and *The Centennial History of North Tarrytown* by Lucille and Theodore Hutchinson were especially helpful to the authors. In addition we are grateful for the assistance and generosity of the following individuals: Ellen Barksdale, Jennie L. Dean, Lucille Hutchinson, Theodore Hutchinson, Christopher Rose, Adelaide Smith, and Robert Yasinsac. Special thanks are extended to Helen Andrew, Beverly Jansen, and Audrey Wheatly.

MaryAnn Marshall
Sara Mascia

Introduction

The historic and picturesque villages of Tarrytown and Sleepy Hollow are nestled on the eastern shore of the Hudson River, 25 miles north of New York City. The two villages have been the site of a Native American settlement and council tree; Frederick Philipse's manor house, mill, and church; and the capture of British spy Major John André by local patriots. After Washington Irving wrote *The Legend of Sleepy Hollow*, the area gained enduring world-wide recognition. Katrina Van Tassel, the Old Dutch Church, Ichabod Crane, and the Headless Horseman are constant reminders of a historic and legendary past.

Since 1889, the Historical Society has been the keeper of the collective memories of the villages of Tarrytown and North Tarrytown (Sleepy Hollow). On December 10, 1996, in celebration of its unique history, the residents of North Tarrytown voted to change the name of their village to Sleepy Hollow. Although possessing a shared past of historic events, cultural institutions, and legendary characters and lore, the two villages remain separate and distinct in their individual identities. The photographs included in this book were generously donated to the Society by members of both villages. Not intended to be a comprehensive history, this volume offers selected images of our community from 1609 until 1947.

Over the years amateur and professional photographers have discovered the unique beauty and character of our two villages. It is primarily through them that our memories are captured and saved. The faces of countless immigrants, merchants, politicians, schoolchildren, and some of the world's greatest philanthropists have been preserved. Photographers E.M. Berrien, Leslie V. Case, E.A. Coles, Catherine McCaul, Fred and Marie Peters, and Alfred L. Trevillian are responsible for many of the images pictured in this photograph album celebrating Tarrytown and Sleepy Hollow.

The Historical Society, Inc.
Serving Sleepy Hollow and Tarrytown
One Grove Street, Tarrytown, NY 10591

One

Beginnings

"It is as pleasant a land as one can tread upon," wrote Henry Hudson as he sailed up the "Great river of the Mountains" in 1609, looking for a Northwest passage to India in his little ship, *The Half Moon*. The Hudson River and its tributary, the Pocantico, drew early settlers to Tarrytown and Sleepy Hollow to farm, trade, and build homes. It was here that Frederick Philipse built a mill, a residence, and a church, and enjoyed great prosperity on his vast holdings that extended north from Spuyten Duyvil to the Croton River and east to the Bronx River. And it was from these beginnings that the villages of Tarrytown and Sleepy Hollow eventually grew.

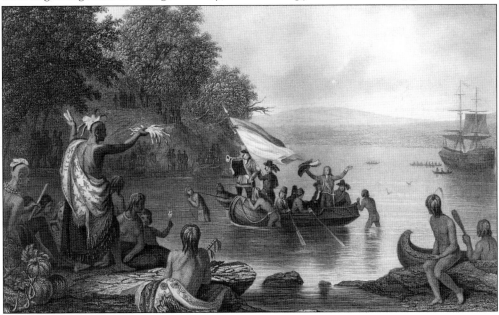

The Weckquaesgeek Indians were a peaceful tribe of hunters, farmers, and fishermen shown as they might have been in this bucolic engraving of *The Landing of Henry Hudson*. They raised maize, pumpkins, and beans, collected oysters, caught sturgeon and other fish in the river, hunted game in the forest, and engaged in trade with the European settlers. Peaceful relations were short-lived, however, as distrust and misunderstanding led to serious conflict and the eventual disappearance of Westchester tribes from the area.

The Hokohongus Tree was a magnificent Chestnut tree that stood for about 300 years in the middle of what is now Philipse Manor. Because the Native Americans believed the tree was a spiritual being, they held their councils there. According to records, the tree was still standing in 1905, but no trace of it remains today.

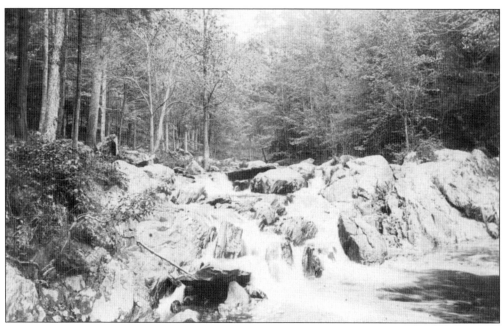

The native people fished and trapped otter and beaver on the banks of the Pocantico River. Later, the river attracted Frederick Philipse for trade and his gristmill, industries such as tool making and Lovatt's silk mill, and Washington Irving on childhood adventures. The beautiful Pocantico, the Indian name for "a run between two hills," is no longer navigable, but remains a living link to the Native Americans that once inhabited the area.

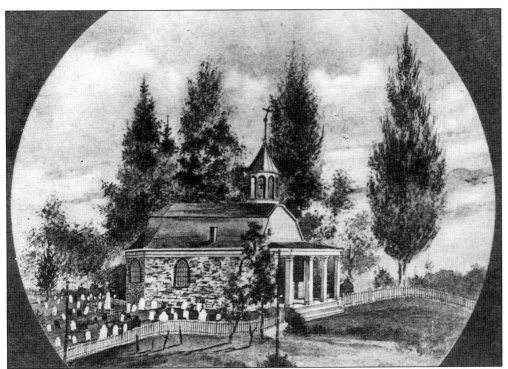

When the Pocantico flooded and destroyed the dam built by Frederick Philipse to power his mill, a slave on the property told of a dream he had that the dam would never hold until a church was built. Philipse had the church built (by 1697) and, according to the story, the dam held fast. The Old Dutch Church is said to be the oldest extant church in the state of New York.

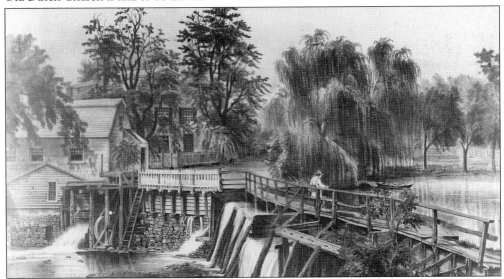

Philipsburg Manor House and Mill was viewed by Frederick Philipse as a source of wealth. His tenant farmers grew the wheat that was ground into flour in his gristmill, and then shipped in his own sloops. They then provided a market for goods brought back on the returning ships. It is said that of his vast holdings, he particularly loved the Upper Mills' rare beauty. When he died in 1702 he left that portion of his estate to his son Adolph.

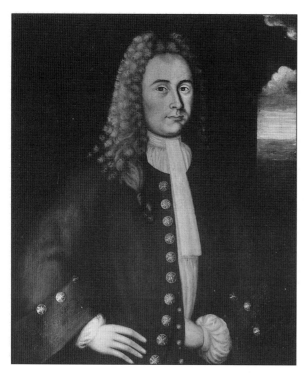

William Beekman, painted on wood by the Beekman family artist, Evart Duyckinck III, hangs in the Victorian Parlor at the Historical Society along with the portrait of his wife, Catherine De Bough Beekman. William was the founder and ancestor of the Beekmans in this country. He arrived here with Peter Stuyvesant in 1646 and married Catharine DeBough in September 1649.

After the Revolution, their great-grandson, Gerard Garret Beekman Jr., increased the family holdings by purchasing about 750 acres of forfeited manor lands at public auction. The Beekman family became owners of more than half of what later became North Tarrytown. These photographs of the portraits appear courtesy of the Frick Art Reference Library.

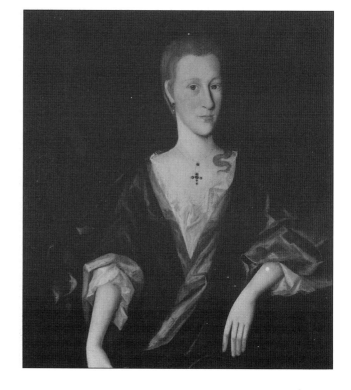

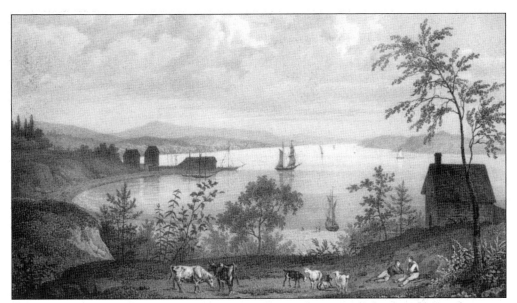

This is one of the earliest views of Tarrytown during the time of the Revolution, from a *c.* 1826 drawing by French artist Jacques-Gerard Milbert, and depicts an idyllic pastoral setting. Although cattle and large farms are no longer visible along its shores, the Hudson River remains, as then, a place to sail or enjoy a peaceful vista of the mountains and hills.

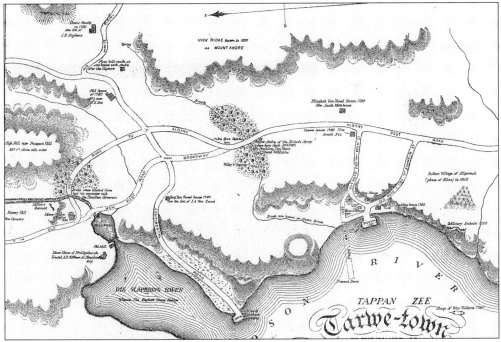

This 1781 map of Philipsburgh Manor from the Historical Society's collection shows Sleepy Hollow and Tarrytown as they looked in the late eighteenth century. The home of James See, the Van Tassel Tavern, and the Old Dutch Church are some of the oldest structures known. The map shows the original route of Broadway. It was moved to the west side of the church in the 1830s.

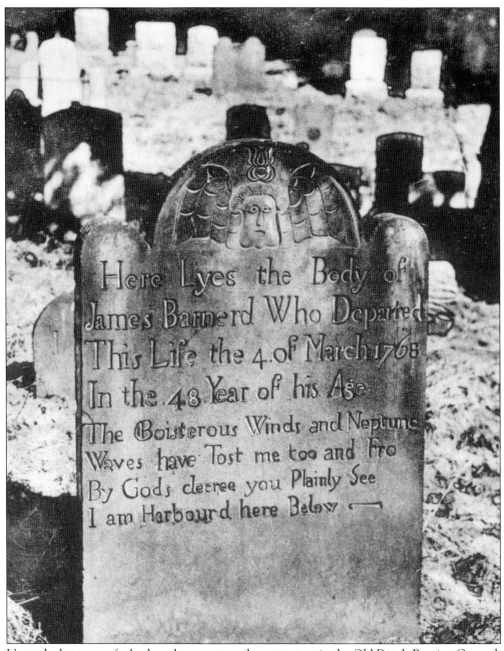

Unmarked graves as far back as the seventeenth century are in the Old Dutch Burying Ground, but only stones from the mid-eighteenth century on are still standing. One of the oldest gravestone's (1768) epitaph refers to James Barnerd's death at age forty-eight by drowning, when a boat belonging to Daniel Martling capsized in the Hudson.

The Boisterous Winds and Neptuns
Waves Have Tost me too and Fro
By Gods decree you plainly See
I am Harbour'd here Below.

Two

The Capture

The 1780 capture of Major John Andre by three local patriots, John Paulding, David Williams and Isaac Van Wart, revealed the treason of Benedict Arnold, changed the course of the Revolutionary War and placed Tarrytown solidly in the history books. A committee to arouse public interest in erecting a monument at the site of the capture was formed in the spring of 1853. Mr. and Mrs. William Taylor, public-spirited landowners and former slaves, donated the land. The stone was quarried and engraved at Sing Sing Prison, Seth Bird provided the foundation of stone and concrete, and the monument was dedicated October 7, 1853.

The members of the Monument Association of the Capture of André pictured here are, from left to right, James S. Millard, Amos R. Clark, D. Ogden Bradley, N.C. Husted, Sam'l Requa, Wm. T. Lockwood, Nelson McCutcheon, James S. See, N. Holmes Odell, and Henry E. Paulding.

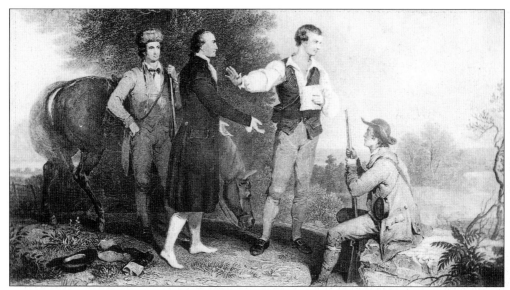

This engraving of the September 23, 1780 Capture of Major André is based on the original painting by Asher B. Durand that was commissioned in 1833 by James Kirke Paulding. Hidden in André's boot were incriminating papers outlining the betrayal of West Point to the British. André was tried as a spy, found guilty, and hanged on October 2, 1780. The congress awarded the three captors a silver medal and a $200 pension for life.

Tarrytown and Sleepy Hollow were small rural communities in 1881, the date of this drawing, which shows the lane where Major John André made his ill-fated ride. No marker designates the actual site of the capture, but it is traditionally believed to be about 200 yards east of the monument near the boundary of what later became the two villages.

The key players in the drama of the capture of Major André shown here in this original portrait are Major Tallmadge, who secured the recall of Andre when the officers holding him prisoner were unwittingly escorting him to meet Benedict Arnold; Colonel Robinson, one of the conspirators planning the takeover of West Point along with General Arnold and Major André; and John Paulding.

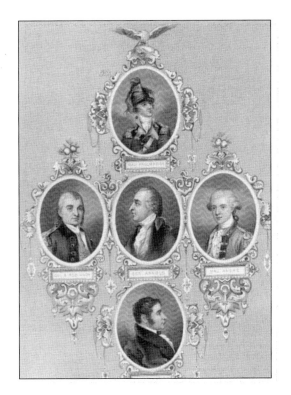

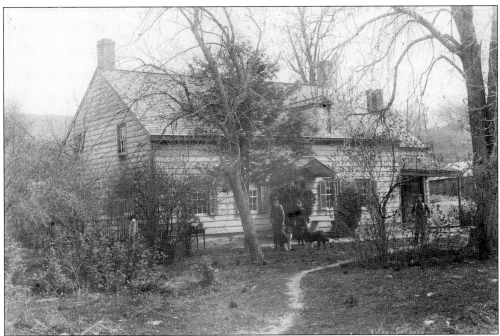

After André had been stopped, the three captors took him to a nearby farm. It is said that he sat on the bottom step in a corner of the kitchen and ate a bowl of bread and milk. After the Revolution the farmhouse was owned by the Reed family. In 1824 it was bought by William Landrine and has been known as the Landrine House ever since.

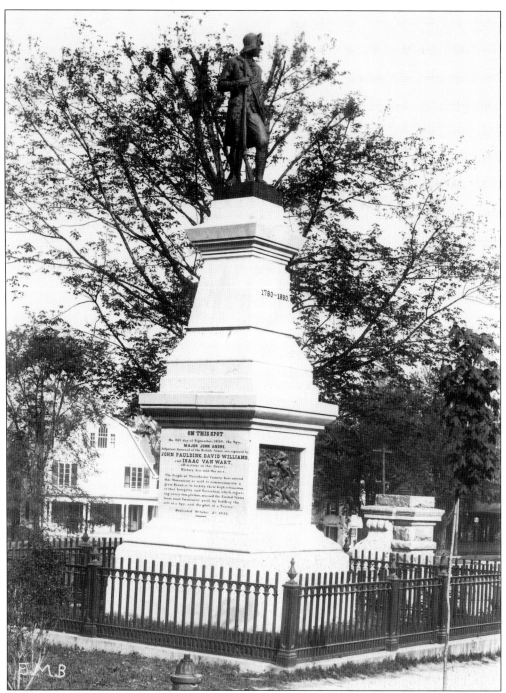

William and Mary Taylor donated the land for the monument erected in 1853. The statue of John Paulding was added in 1879 . The engraving on the south side of the monument reads in part: *The people of Westchester County have erected this Monument, as well to commemorate a great Event, as to testify their high estimation of that Integrity and Patriotism which, rejecting every temptation, rescued the United States from most imminent peril by baffling the arts of a Spy and the plots of a Traitor.*

Three

The Homefront

From the time of the Revolutionary War to twentieth century conflicts, the men, women, and even children of Tarrytown and North Tarrytown have answered the call to assist in every phase of the war effort at home and abroad. Residents worked in factories, supported bond drives, participated in civil defense organizations, and sent their sons and daughters to war in the name of democracy and freedom.

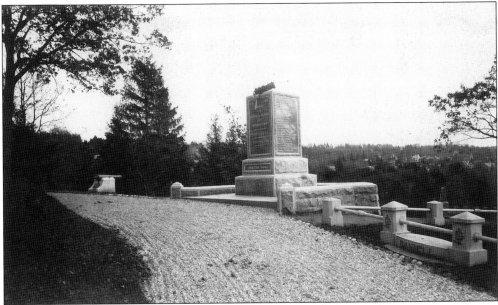

A monument to area Revolutionary War soldiers on Battle Hill in Sleepy Hollow Cemetery was dedicated October 19, 1894, and lists ninety-two soldiers' names. The inscription reads: *In memory of the Officers and Soldiers of the Revolution who by their valor sustained the cause of liberty and independence on these historic fields, 1776–1783.*

Abel T. Stewart was pastor of the Old Dutch Church when the first Civil War draft laws were enacted in 1863. Riots broke out in New York City, and rioters then headed for Tarrytown to burn the house where the Westchester draft records were kept. Women, children, and African-Americans were evacuated to Pocantico Hills while the Reverend Stewart, Captain Oscar Jones, and several local citizens persuaded the rioters to return to New York City peacefully.

The Grand Army of the Republic Ward B. Burnett Post #496 was organized on July 1, 1884. Pictured here in one of their last photographs are: (seated) John Burd, unknown, Arthur Humphrey, Mr. Baker, and George Burd; (standing) Mr. Wilson, G.E. Storm, Bishop Armstrong, and Mr. Buffit.

Robert Hayes Carter, a veteran of the Spanish-American War, came to Tarrytown with his family after the turn of the century. He was a long-time employee of the David L. Luke family.

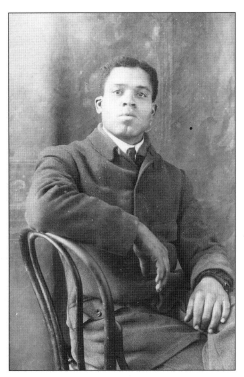

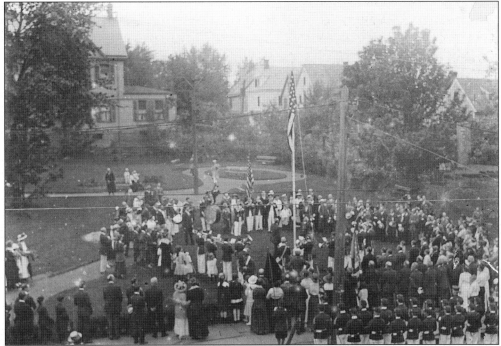

A flag ceremony commemorating our entry into World War I in 1917 was held in Tarrytown on the southwest corner of Main and Broadway, where a park was once located. E.W. Harden purchased the old Dean corner in April 1912, and turned it into a beautiful park which was enjoyed until 1923, when the property was developed.

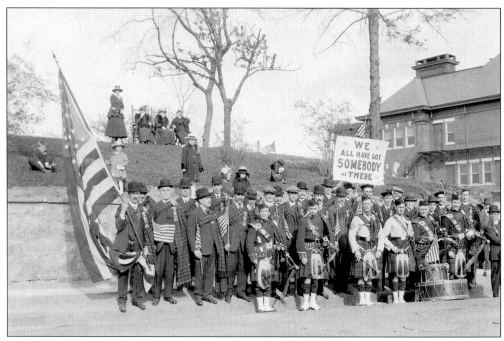

A Wake-Up parade to encourage recruitment for the armed forces was held in both villages on May 12, 1917, a month after the United States declared war on Germany. The Campbell Clan, shown here with their bagpipes, joined fire departments, bands, schoolchildren, and village officials as they marched in support of the war effort. At the close of the festivities, 5,000 people gathered at St. Teresa's Park to hear patriotic speeches.

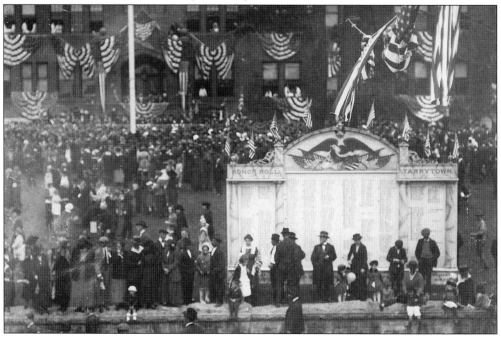

Following the war, the people of Tarrytown gathered to dedicate the World War I Honor Roll in front of the old Washington Irving High School (now Landmark Condominiums).

Young men and women both volunteered and were called to service after the bombing of Pearl Harbor in 1941. Lt. Charles J. Husted Jr., son of Mr. and Mrs. Charles J. Husted of Millard Avenue in Philipse Manor, was reported lost after his plane failed to return to his carrier, November 11, 1943.

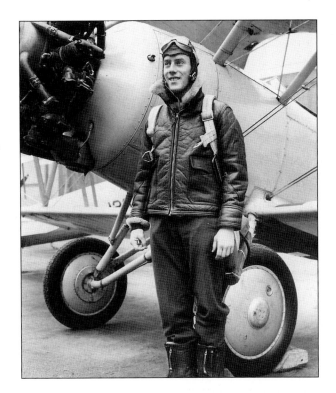

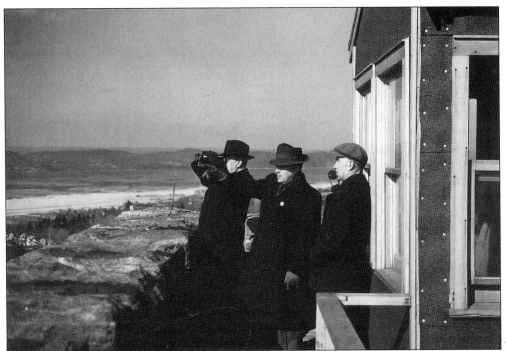

The Axe Castle in Tarrytown, the highest lookout in the area, was used during World War II by Civil Defense plane spotters. Shown here at the top of the Castle, with a view of the river and the lighthouse in the background, are Alex Kilmer, Fred Warren, and Chief Warden Joe Rizzi.

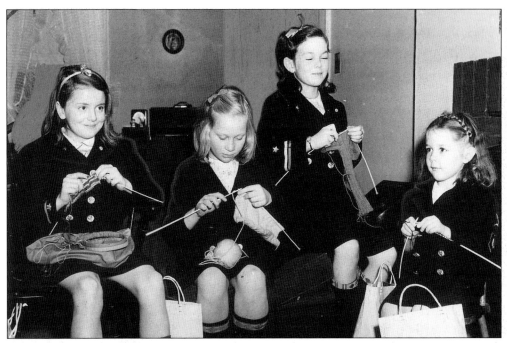

These little girls from Philipse Manor, members of the Junior Auxiliary of the Tarrytown Branch of the British War Relief Society under the direction of Helen Hoar, are busy knitting socks and other warm clothing to be sent to bombed-out children in Great Britain. Pictured are Peggy Minich, Britt Marie Sterner, Jane Kennedy, and Frances Kennedy. This picture appeared in *Tarrytown Daily News*, January 8, 1942.

Catherine P. McCaul and Genevieve V. Valerious were members of the Tarrytown branch of the World War II Westchester Defense Council, shown here in front of the fountain on Depot Square.

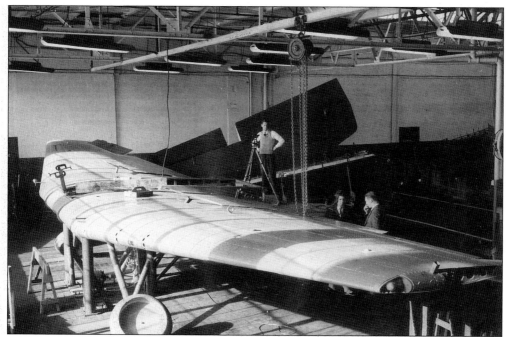

The men and women who worked in the factories that supplied our armed forces with weapons, planes, and tanks were vital to the war effort. The conversion of the General Motors plant in North Tarrytown from the manufacture of automobiles to airplane parts was one of the success stories of the war. At the Eastern Aircraft Division of General Motors, Tarrytowners produced wings and several other large assemblies for the Avenger torpedo bomber.

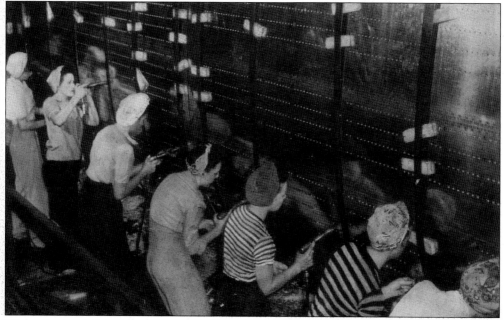

Women were an important new source of labor at the North Tarrytown plant during the war. By 1943, more than 2,900 women had been put on the payroll, compared to a peacetime total of 120. The Tarrytowns' own "Rosie the Rivetters" are pictured here.

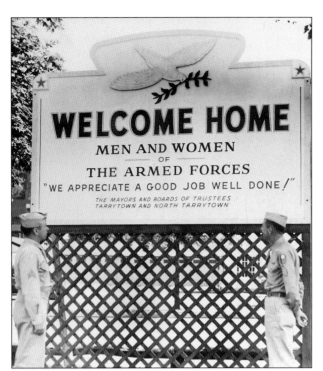

Sgt. Fred Rutzenburg of Pocantico Hills and Sgt. John Barrett of North Tarrytown join the people of Tarrytown and North Tarrytown in welcoming the returning men and women from the war in May 1945.

This photograph by Catherine P. McCaul shows the World War I monument in front of the Pierson School (now Landmark Condominiums), with the Reformed Church of the Tarrytowns in the background. The inscription echoes the sentiments of survivors of all the wars: *Let those who come after see to it that their names be not forgotten . . .*

Four

Village Scenes

The picturesque scenes of the villages have always attracted artists and photographers to Tarrytown and Sleepy Hollow. The lives of ordinary people and where they worked, shopped, and traveled to business and recreation are captured and preserved in these valuable photographs of an era long past.

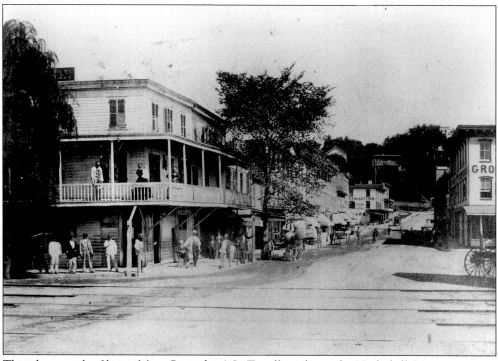

This photograph of lower Main Street by A.L. Trevillian shows the Underhill Section as it was in 1867. Washington House/Hotel on the corner of West Main Street and Railroad Avenue, operated by Benjamin Ingalls, boasted rare wines and excellent liquors. Before the turn of the century many well-known prize fighters, including Pinky Evans, trained at the hotel. The Revere House/Saloon is adjacent, and Smith & Morris Grocer is across the street.

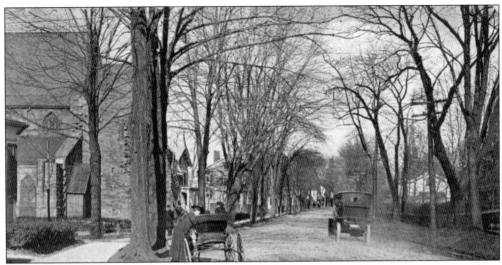

This view shows Broadway, North Tarrytown, looking north from the Captors' monument around the turn of the century, before the streets were paved. St. Marks Episcopal Church (now the Immaculate Conception R.C. Church) is on the corner of Broadway and College Avenue. One of the Irving Institute buildings, a private boarding school, is shown on the right.

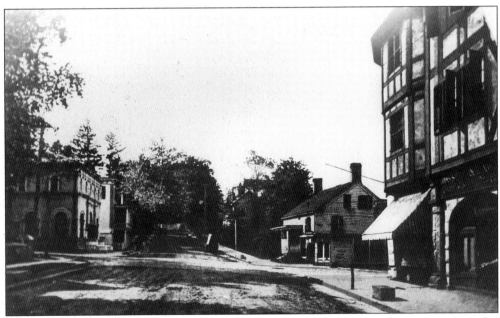

This view shows Broadway, Tarrytown, looking south, c. 1908. The Dean House, on the right, was once a tea room and a post office. Westchester County Savings Bank, on the left, was built in 1898 in the Spanish Renaissance style and is the oldest savings bank in Westchester. To the front right is the Washington Building, built about 1894.

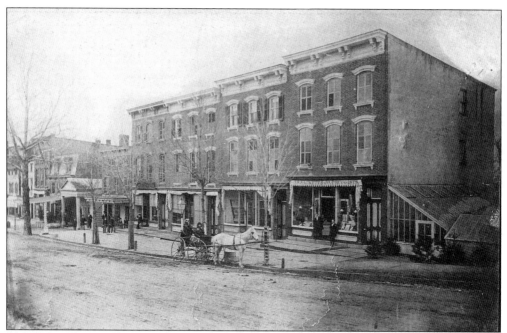

This view of Main Street, Tarrytown, shows Sackett & Co. Druggists and the old Pierson Greenhouses. J.B. Sackett offered popular remedies for common ailments. At Christmas time, they sold tier upon tier of balsam boughs. The columned entry on the left was "Squire" Elias Nann's Hat Store (later Flockhart's) that also served as a court room and voting room. The four connecting buildings in the center are still standing.

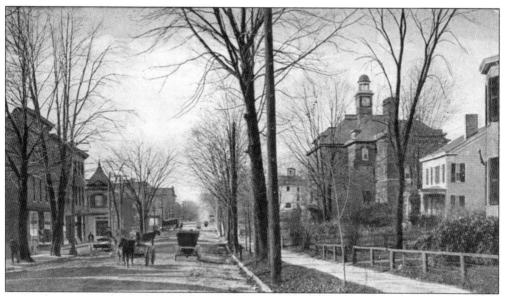

Beekman Avenue, formerly Continental Road, was built by Cornelia Beekman. It was 66 feet wide and was not paved until 1909. Helen Gould donated the elegant four-sided clock to the North Tarrytown School. At midnight on the first night that it chimed the firemen mistook it for an alarm and started to dress for a fire. Farrington's Drug Store, a gathering place for young people, was on the corner of Washington Street and Beekman Avenue.

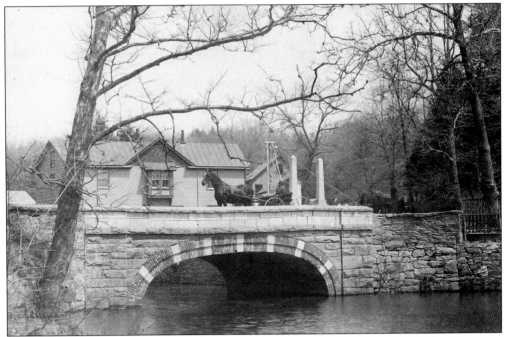

"Pony" Wilson, shown driving George E. Storm's mare, is on the bridge over the Pocantico on Broadway in North Tarrytown about 1881. The building in the background is the Sleepy Hollow Granite & Marble Works established by S.J. Sackett where the Revolutionary Soldiers' Monument was produced.

James Trevillian and his large family once lived on Franklin Street (top right). At the top left can be seen the Shotwell house, on the corner of Franklin and Windle Park. The lower right house belonged to Mary Duffy. Franklin Street, named in honor of Benjamin Franklin, was originally Water Street. This photograph, taken around the turn of the century, shows the street before it was paved.

The small house in the middle of this photograph is 27 Chestnut Street, North Tarrytown. The 1899 North Tarrytown Brick School with the clock tower is visible in the background.

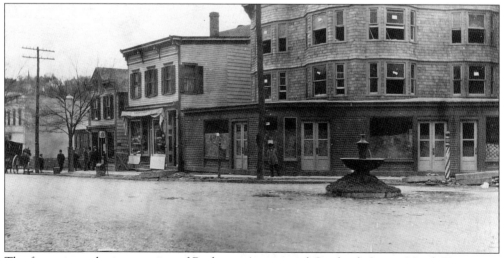

The fountain at the intersection of Beekman Avenue and Cortlandt Street, North Tarrytown, shown here c. 1891, was donated by the Rev. John Barnhart, for whom Barnhart Avenue was named. It was constructed of stone and iron and had a large basin for horses, and a smaller one for dogs and cats. People could also drink out of the spigot.

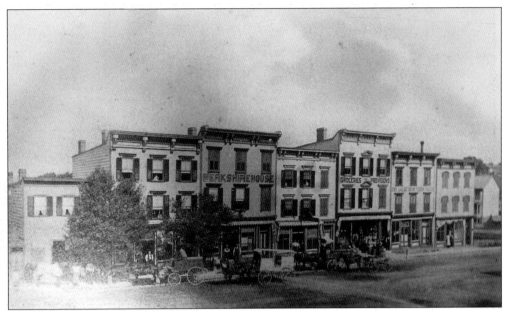

Orchard Street, shown here c. 1884, was at one time a major business district, and was named for the huge apple orchard that was on this site until 1845. The Berkshire House, located at 17 Orchard Street, sold wines and liquors. It was named by its owner, John McCarty, who came from Massachusetts. It also had a billiard parlor and a bowling alley. At nearby 21 Orchard Street, the Germania House also sold foreign and domestic wines.

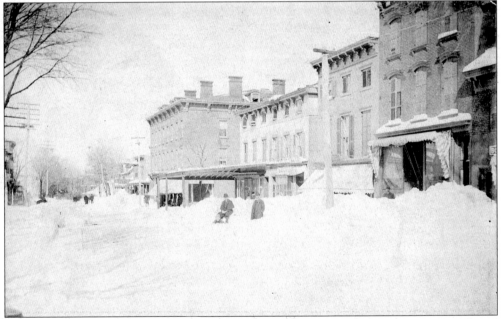

Washington Street and the north side of Main Street, Tarrytown, during the famous blizzard of 1888 is pictured here. The blizzard lasted three days, with 21 inches of snow and high drifts covering storefronts. To navigate streets blocked by drifts, townspeople dug 8-foot tunnels illuminated with Japanese lanterns. Day's Bakery (now Alma Snape's Flowers) was blocked by the huge drifts.

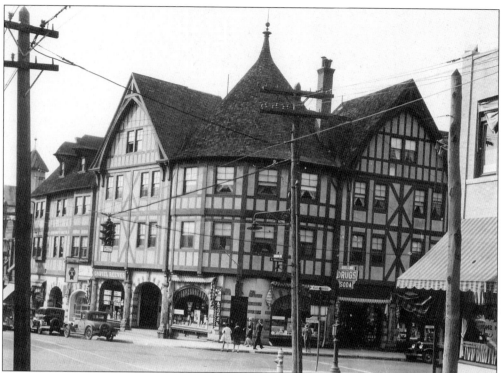

The Russell & Lawrie Corner was once the site of the Couenhoven Inn dating to Revolutionary War times. George Washington spent the night at the inn before he traveled to New York City to witness the evacuation of the British troops on November 19, 1783. The inn was demolished and the Washington Building was erected in 1894. The Russell and Lawrie Drug Store, with its famous grand onyx soda fountain, occupied the site until 1968.

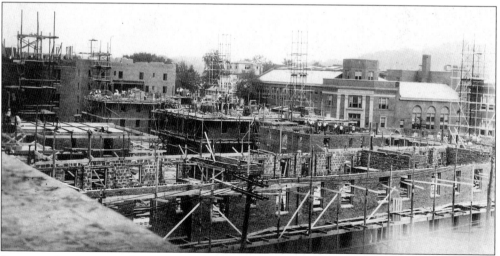

Because of a shortage of apartments for Chevrolet workers' families, John D. Rockefeller Jr. agreed to back an apartment complex. The five-story Van Tassel building is shown here under construction in 1928. Two-hundred-and-forty-two units, a large courtyard, and interior gardens were planned. The bricks were imported from Holland. The $2 million structure was named after Katrina Van Tassel by Abby Rockefeller.

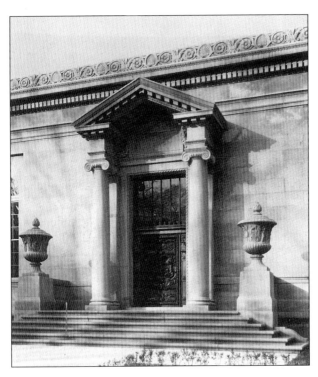

The Warner Library was a gift of the Warner family to the people of the Tarrytowns. The exterior is of Indiana limestone with elaborately carved entablature. The finest feature is the Florentine bronze door depicting the coronation of Venice as Queen of the Adriatic in massive relief. The hinge mechanism for this 1,000-pound door was designed by Mr. Warner. The library, which serves both villages, was dedicated February 1929.

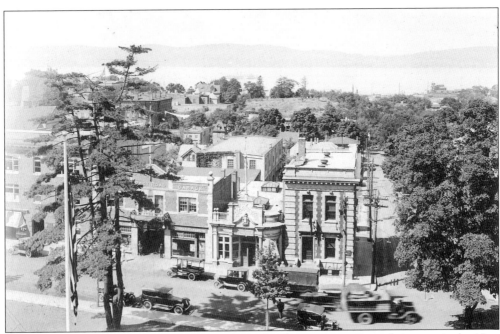

This view shows several buildings on Broadway. On the corner at Central Avenue is the New York Telephone Company building constructed in 1902, and adjacent to that structure is the former Tarrytown Post Office (1907–1926). The Old Post Road Garage is shown on the left. The photograph was taken c. 1910–1915.

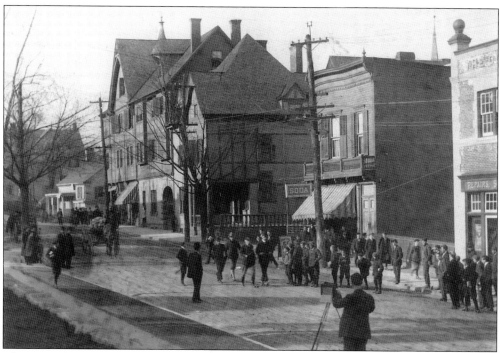

This 1909 photograph taken on Broadway across from the Old Post Road Garage shows Edward Payson Weston, age seventy-one, the Great American Pedestrian, head and walking stick held erect, on his walk from New York City to San Francisco. After spending the night at the Florence Inn, he continued on his journey.

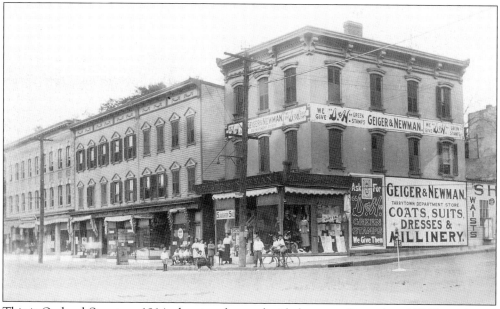

This is Orchard Street, *c.* 1914, showing the south side between Central and Wildey, when it was a growing hub of business. Left to right are Sperry & Hutchinson, 70 N. Orchard, Premium Stamps, National Grocers, a shoe store, and Geiger & Newman, a Tarrytown department store.

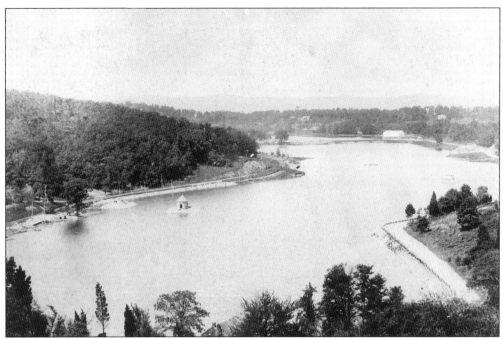

The lower lake was completed in 1888. Spread over 50 acres and holding 70 million gallons of water, it is still used as part of Tarrytown's water supply. Two artesian wells were sunk and the foundations are still there today. Note the Pocantico Railway on the southwest shore of the lake. Thirty trains a day passed by the Tarrytown Lakes in 1900.

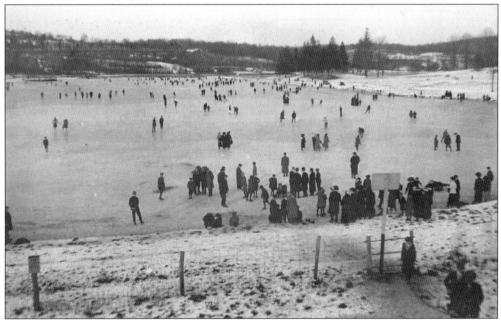

At one time the Tarrytown upper lake froze over almost every winter and made ice skating a popular winter sport, as shown in this c. 1915 photograph. The heights, as the area was known, were illuminated for night skating by strings of lights. The area in the foreground is where the skating shed was located in later years.

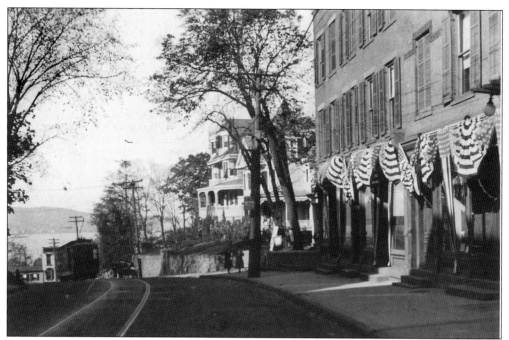

When the White Plains/Tarrytown Trolley was planned, the Main Street merchants fought hard to have the trolley pass through the business district. The track ran up Main Street and Neperan, across Altamont Avenue to Benedict, and on to White Plains. It had its first run October 23, 1897. The last trolley operated November 16, 1929, amid a great ceremony, and yielded to the arrival of the bus.

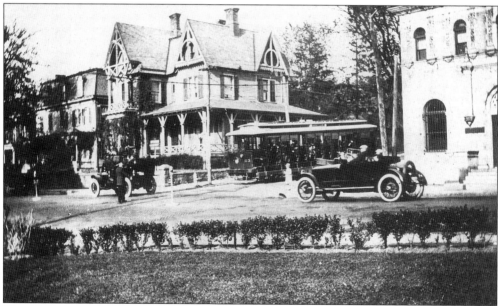

This 1925 photograph shows the intersection of Broadway and Neperan Road with the residence of Dr. Richard Coutant on the northeast corner and the Westchester Savings Bank on the southeast corner. The trolley pictured above, a single-track electric-powered trolley line with poles and wires, ran from Tarrytown to White Plains.

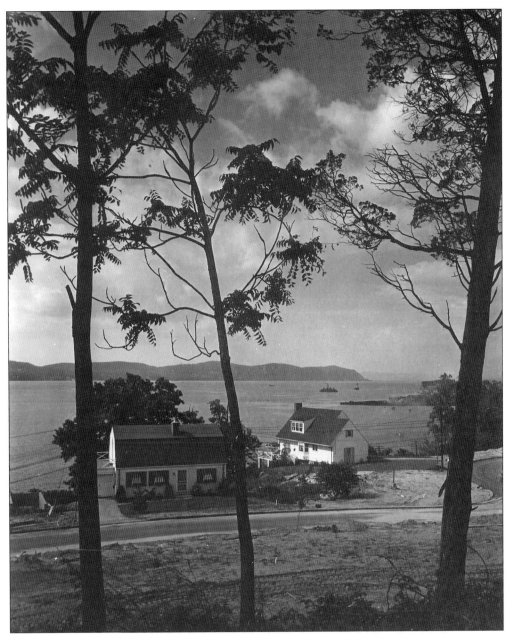

County Homes Inc. signed a contract and the Village of Tarrytown for developing Tappan Landing in 1941. A development of seventy new homes was started in 1939 and a model home is pictured here. The view shows the lighthouse, the Hudson River, and General Motors on the middle right with the Palisades in the background. David Swope named the area Tappan Landing after an old Hudson River Landing in Piermont, the port of the Dutch settlers of Tappan.

Five

Houses on the Hudson

From small farmhouses to the mansions and castles of millionaires, the houses of Tarrytown and Sleepy Hollow display a variety of architectural styles. The many historic homes of early residents attest to our agrarian beginnings and the numerous houses and mansions overlooking the Hudson constructed during the nineteenth and twentieth centuries confirm our development as a vital suburban community. The photographs presented here illustrate the diverse nature of the domestic and public buildings in the two villages.

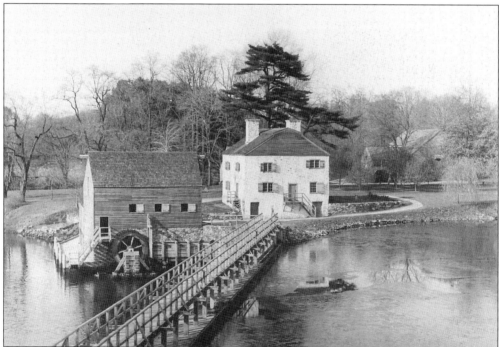

The Philipsburg Restoration in Sleepy Hollow was once part of the Manor of Philipsburg. Frederick Philipse's son Adolph inherited the property in 1702. When Adolph died, the Manor passed to Frederick II and a year later to Frederick III, who sided with the crown in the Revolutionary War and lost the entire estate to forfeiture. The house, gristmill, wharf, and dam have been restored to the way they were in Adolph's time.

The Capt. Daniel Martling home, built *c.* 1758, was situated at White and Water Streets, Tarrytown. It fronted directly on the river near Martling's Landing. His two sons, Abraham and Isaac, both served in the Revolutionary War, and it was here that Tarrytown's first murder occurred when Isaac Martling was shot by a British sympathizer. His gravestone in the Old Dutch Burying Ground recorded the event: ". . . inhumanely slain in 1779 by Nathaniel Underhill."

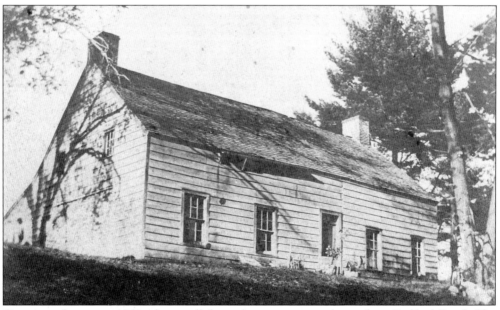

Constructed prior to 1780, this small frame house was once located on Bedford Road. The home of James See, the grandfather of Alice Ackerman, wife of the first lighthouse keeper, this house was depicted on early maps of Sleepy Hollow.

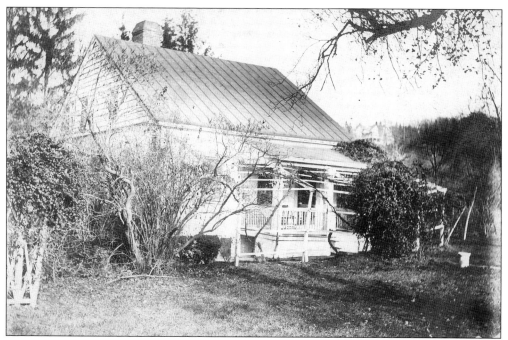

Many claim that Washington Irving used the house and tavern owned by John and Eliza Van Tassel as the model for the home of his literary heroine Katrina Van Tassel. It is said that when Jacob Mott purchased the house, Irving requested that the owner retain the original form of the c. 1712 structure. In 1896 the property was acquired by the village as the site for the first Washington Irving High School and the house was subsequently demolished.

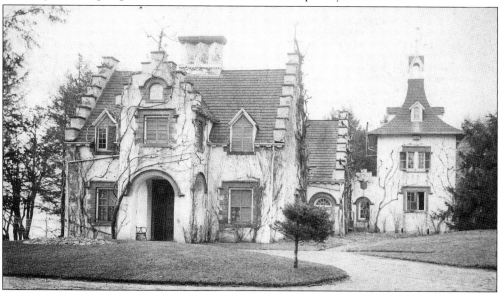

In his youth, Washington Irving visited the local countryside a number of times. While he had always wanted a house in Tarrytown, he did not purchase one until 1835 when he was fifty-two years old. Built by Wolfert Acker in 1656, the old Dutch farmhouse, known as Wolfert's Roost, was owned by the Van Tassel family in the late eighteenth century. After Irving acquired the property, he renamed it Sunnyside and spent two years remodeling the house.

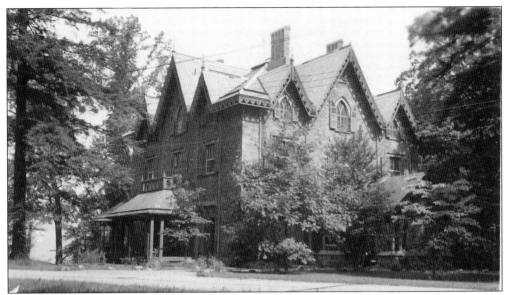

Pokahoe, also known as the Fremont house, was built in 1847 by James Watson Webb. Ambrose Kingsland acquired the house and its 53 acres in 1864. Jessie and John C. Fremont (the Pathfinder) bought the house the next year and lived there until about 1875. The house was reduced in size by a third in the 1950s. Later renovated by various owners, it is now on the National Register of Historic Places.

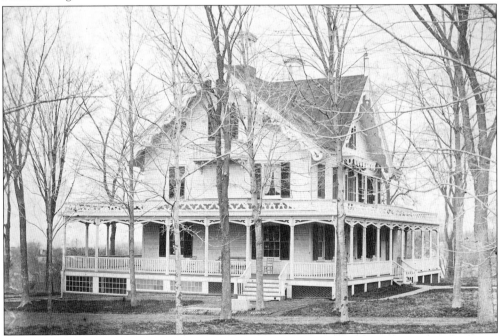

The home of General James Benedict, Rosehill, was constructed in 1835, and was located on South Broadway. Benedict gave the house to his daughter, Ann Augusta, and her husband, Captain Edward Brown Cobb. In the 1920s their son, Augustus Cobb, sold it to the Tarrytown school district. Rosehill was moved to a site on Franklin Street, where it was demolished c. 1950, and the second Washington Irving High School was built on the original house site.

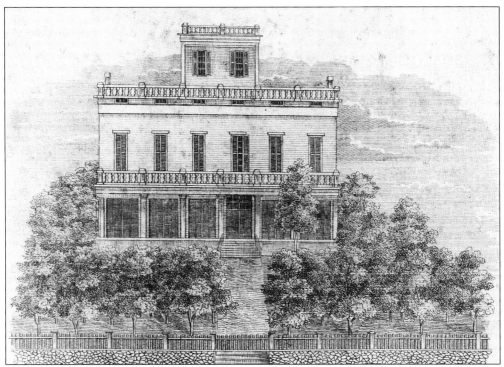

Nathan Cobb was a leading packet ship master and owner when he came to Tarrytown in the mid-nineteenth century. He built a large house, pictured above, on the west side of Broadway in the 1850s. Although Captain Cobb continued to engage in international trade, he was also very involved in local concerns. In 1851 he donated $4,000 to the Village of Tarrytown for the construction of a modern brick school.

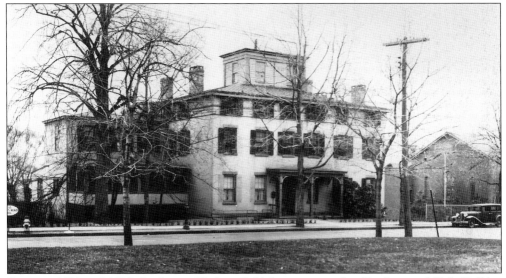

Between 1880 and 1890 the former Nathan Cobb house was utilized by Jane and H. L. Bulkley as a school for girls. In 1898 the Episcopal Church purchased the building and opened the St. Faith's Home for unwed mothers. From that date to the 1970s St. Faith's offered help and a home to countless young women and abused children.

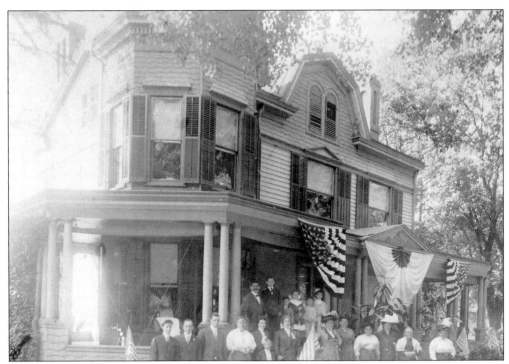

This home, once owned by the Hyman Levy family, is located on the corner of Chestnut Street and Broadway in North Tarrytown. It is shown here decorated for the Hudson/Fulton celebration in September 1909.

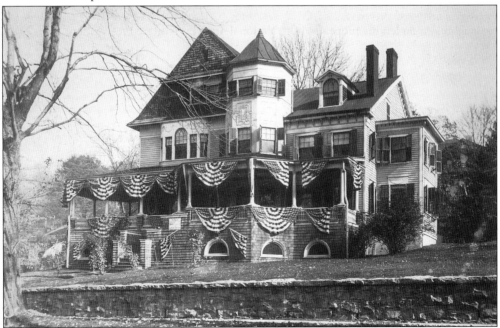

Shown here decorated for a village celebration, the house at 90 North Broadway was once the home of the Women's Civic League. Later remodeled, the house became the location of Dwyer Funeral Home.

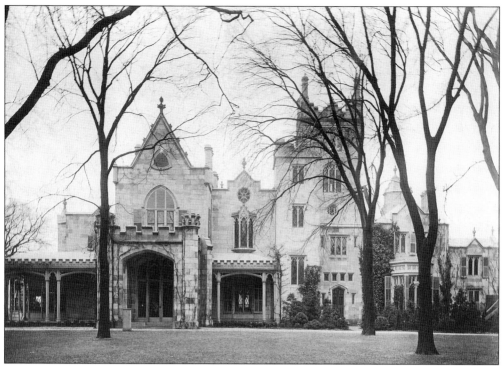

In 1838 William Paulding built a large Gothic Revival residence overlooking the Hudson River. Lyndhurst, as it is now named, was sold to George Merritt in 1864 and the mansion was enlarged by the original architect, Alexander Jackson Davis. Jay Gould, a railroad tycoon and financier, purchased the estate in 1880. It remained in the Gould family until the 1960s when his daughter Anna left the property to the National Trust for Historic Preservation.

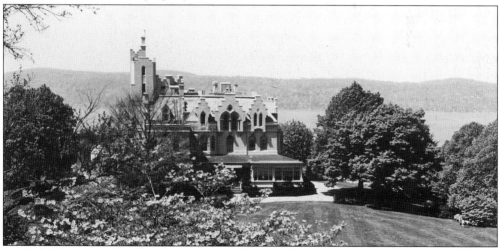

In 1902 Julian F. Detmer purchased a large estate and mansion on Benedict and Prospect Avenues. Built in 1895 by Franklin Petit, the twenty-two room residence was patterned after a Normandy Chateau. Detmer, a woolen industry tycoon, named his estate Edgemont. He enjoyed landscaping and gardening and made his property a showplace. The estate was eventually turned into a commercial nursery and the public was free to visit the grounds until the mansion was destroyed by fire in 1971.

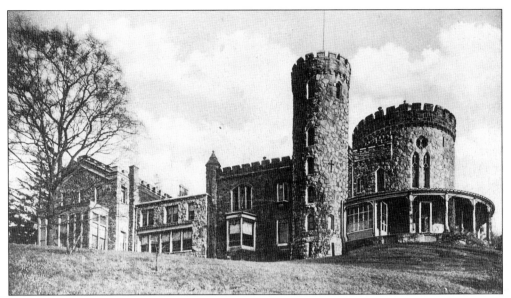

Architect Alexander Jackson Davis designed a palatial mansion for John J. Herrick in 1854. Ericstan, or Herrick's Folly as it was called locally, overlooked the Hudson from Castle Ridge in Tarrytown. Following severe financial reverses, it was sold by the steamboat businessman in 1861. The castle had a series of owners until it was purchased by Miss Cassity Mason in 1895. It was then operated as a school for girls until her death in 1933.

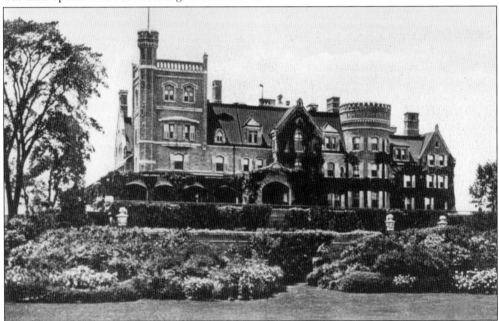

William Rockefeller purchased the Aspinwal estate in 1886 and built Rockwood Hall, a magnificent castle on the Hudson River. Situated on 1,000 acres, it was known for beautiful landscapes, rare birds, and elaborate parties served by liveried servants dressed in eighteenth-century costumes. After William died in 1923, the property became a country club which failed during the Depression. The house was subsequently demolished and the land turned into a public park by Laurance Rockefeller.

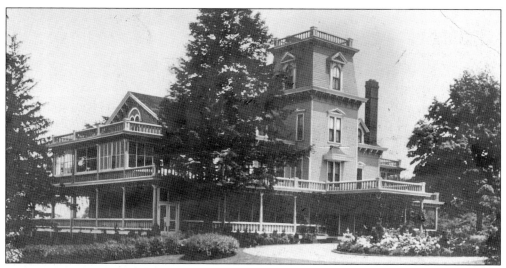

After William Rockefeller purchased his Hudson River estate, his brother John began acquiring farms and properties that eventually totaled 3,500 acres. John D. Rockefeller Sr.'s country retreat, the Parsons-Wentworth house in Pocantico Hills, was once part of the estate. After it burned in 1902, plans were made to construct Kykuit.

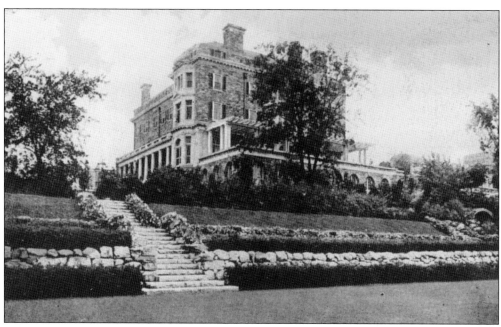

Kykuit (Dutch for "lookout"), situated on a hill on the Pocantico Hills estate, was completed in 1913 by John D. Rockefeller Jr. for his parents. Over the years the property was developed to include over sixty buildings, a golf course, a recreational facility called the Playhouse, and extensive formal gardens featuring classical and modern sculpture.

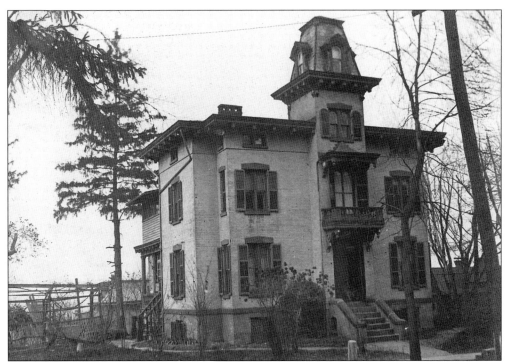

Jacob Odell built his Grove Street house as a wedding gift for his bride in 1848. The hitching post and step for visiting carriages was still in use at the time of this picture, *c.* 1912. The Historical Society acquired the property through the generosity of John D. Rockefeller II in 1952. Now a museum and research center housing local historical collections, the Historical Society is open to the public on a regular basis.

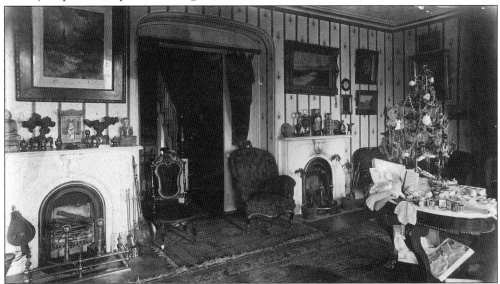

Leslie V. Case, superintendent of the Tarrytown Schools for thirty years, purchased the Odell house in 1918. This photograph, *c.* 1920, shows the formal parlor of One Grove Street decorated for the Christmas Holidays in the Victorian manner. Now used as a museum, the Victorian Parlor at the Historical Society retains its nineteenth-century charm.

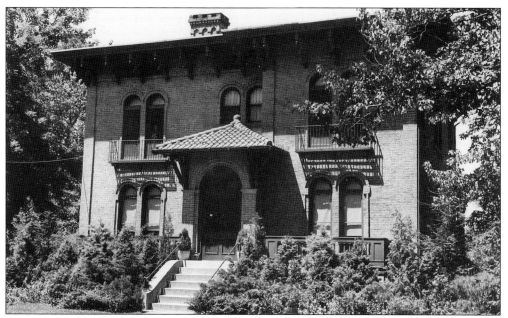

The Hay House, one of five houses in the Grove Street Historical District, is listed on the National Register of Historic Places. Mr. and Mrs. DeWitt Clinton Hay acquired the Italianate-style house in 1872 when the street was called Goose Street. Hay House was at one time the headquarters of the Tarrytown Historical Society.

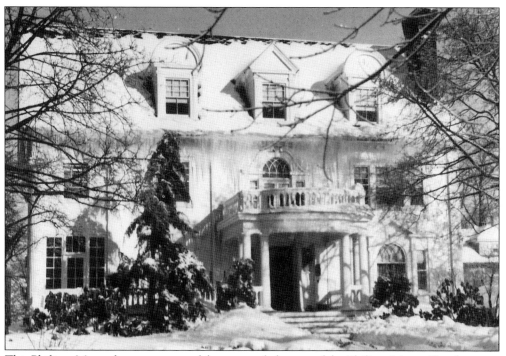

This Philipse Manor home was one of the very early houses of the Philipse Manor Development Company. A 1914 promotional brochure described the area as completely free from mosquitoes with a river view from every property. This photograph was taken by J. Floyd Smith, *c.* 1941.

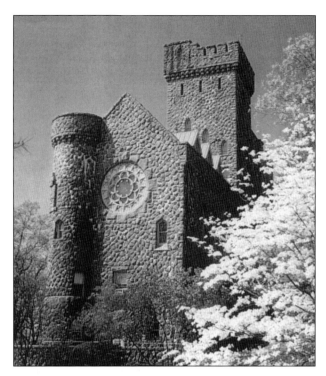

The Castle at Tarrytown, formerly Carrollcliffe, was built in 1900 for General Howard Carroll. It is situated on one of the highest points in Westchester, and is visible from much of Tarrytown. The main tower rises more than 75 feet, and the grounds are enclosed by stone walls, trees, and luxurious plants. Pictured here when it was owned by E.W. Axe & Co., the Castle has been completely renovated as a luxury inn and restaurant by its new owners.

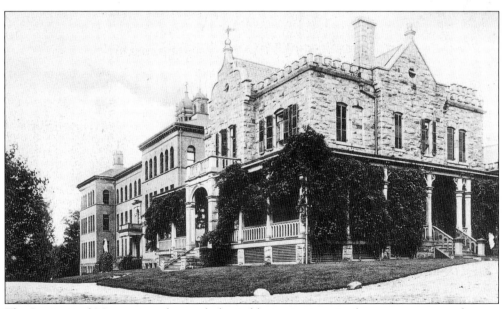

The Institute of Mercy, one of several charitable institutions in the area, was an orphanage located on Wilson Park Drive in Tarrytown. It was operated by the Sisters of Mercy from 1893 until it closed in 1945. The building no longer stands.

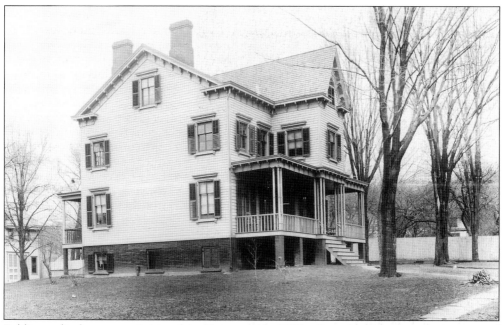

Public medical care was initiated in Tarrytown in 1890 when the Provident Association of Tarrytown provided medical assistance in a room of the Martin Smith House on Main Street. Although this effort failed, the group was reorganized as the Tarrytown Hospital Association and opened a facility in a house on Wood Court. Dr. Richard Coutant was the chief of staff and the hospital had a horse-drawn ambulance for emergencies. The old Tarrytown Hospital was used until 1911.

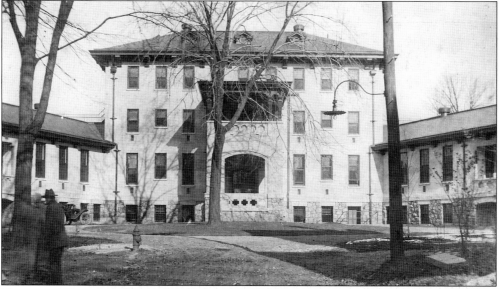

The second Tarrytown Hospital was constructed on Wood Court, just east of the older building. Although it was augmented with several additions, the hospital could not keep up with the medical needs of the rapidly growing community. In 1955 a much larger Phelps Memorial Hospital opened and the Wood Court facility became Tarrytown Hall, a home for the elderly and convalescent.

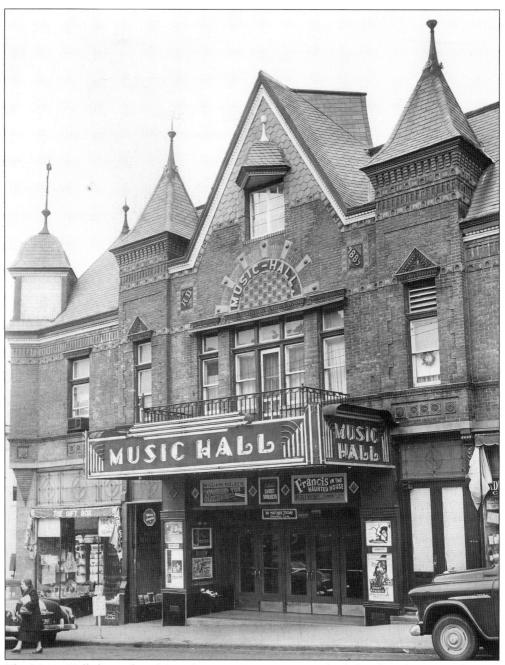

The Music Hall, located on Main Street in Tarrytown, was built by chocolate manufacturer William L. Wallace. When it opened on December 12, 1885, the main entrance was located on Kaldenberg Place. Used primarily for musical performances and, after 1901, viewing motion pictures, the hall was also the location of dances, balls, and roller skating events until the sloping floor was installed in the 1920s.

After leasing the hall for ten years, it was purchased in 1925 by Robert Goldblatt, another of Tarrytown's great benefactors. Currently, the Music Hall is the oldest operating theater in Westchester County and remains one of the community's most recognized landmarks.

Six

Working Men and Women

During the nineteenth and twentieth centuries, Tarrytown and Sleepy Hollow became busy centers of industry and commerce. After the railroad was introduced, the number of local businesses grew at a rapid pace. Along the riverside and main streets a variety of merchants opened small shops and markets. One extremely busy hub of activity was Orchard Street, which was formerly located in the lower portion of Tarrytown. Much like its neighbors, Main Street, Beekman Avenue, and Cortlandt Street, Orchard had shops offering a wide variety of goods and services to the people of the villages.

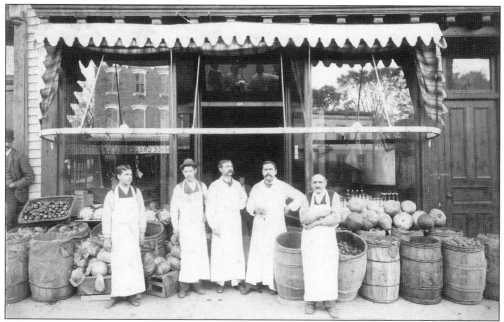

Richters Central Market was located at 65 Orchard Street. Shown here in 1892 are, from left to right, Frank C. Richter (age fourteen), unknown, Charles Richter, Robert Richter, and Gustave Richter. One of two butcher shops the brothers owned on Orchard Street, the Central Market was located here until the 1950s.

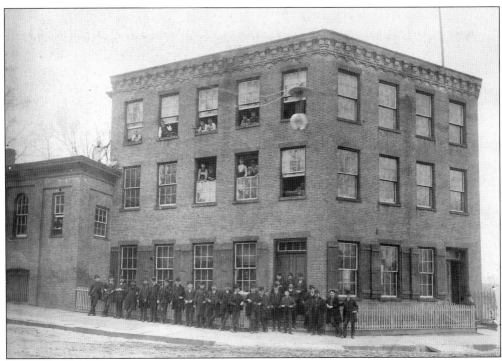

Originally located on the west side of Washington Street, the Silver Shoe Factory moved to Tarrytown in 1871. David and George Silver manufactured high quality footwear until the 1890s, when the employees voted to unionize and the factory was closed. Shown here in 1887 when electric lights were installed, the factory was producing up to 200,000 pairs of shoes per year.

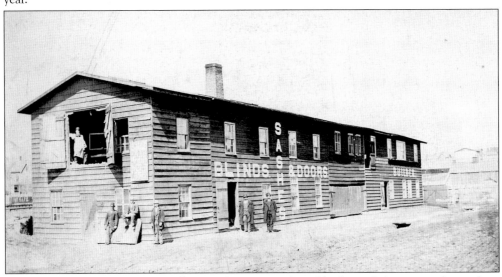

Morgan Purdy's two-story sawmill, specializing in sashes, blinds, and doors, was located on Cortlandt Street. From the 1850s to the 1890s, Purdy employed six to eight assistants who operated the steam-powered mill. The photograph above was taken *c.* 1880 when Purdy was elected a trustee of North Tarrytown. Shown are, from left to right, Briggs DeRevere, John Patterson, Charles Purdy, Charles Boyce, Morgan Purdy, and Richard Livingston.

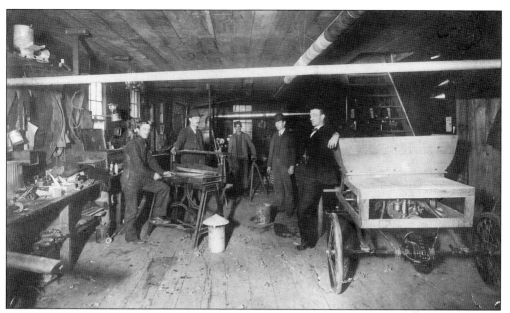

Always a hub of activity, "Beek" Walton's Blacksmith Shop was located on Beekman Avenue.

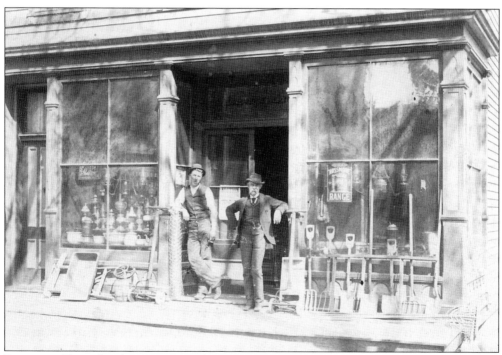

Benjamin Clapp's hardware store was located on Cortlandt Street. Shown here in 1900, Clapp, at right, manufactured tin, sheet iron, and copper. In his shop he also sold large items such as furnaces, ranges, and stoves.

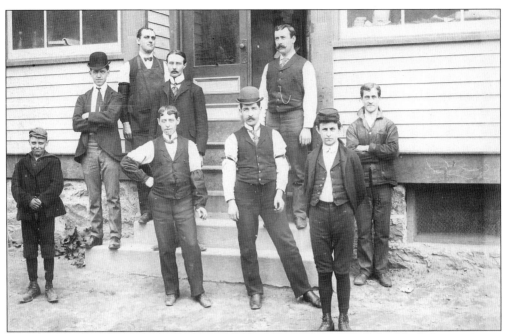

This photograph shows the first staff of the Mount Pleasant News located on the northwest corner of Valley Street and College Avenue. Shown are, from left to right, unknown, Wallace O'Dell, G. Fred Van Tassel, unknown, Odell Taxter, unknown, Mr. Fay, unknown, and Claude Taxter. Organized in 1897 by O'Dell and Van Tassel, the weekly paper sold for 5¢ a copy. In 1912 the paper became the *Tarrytown Daily News* serving both villages.

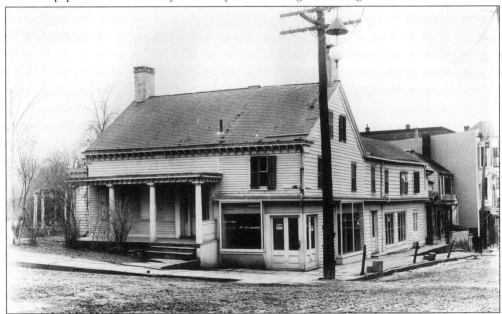

Located on the southwest corner of Broadway and Main Street, Deans Corner Store was in operation from the first decade of the nineteenth century to 1900, when the building was used as a tea room. Named for the Dean family who operated the store, the building also served as the village post office for much of the early nineteenth century.

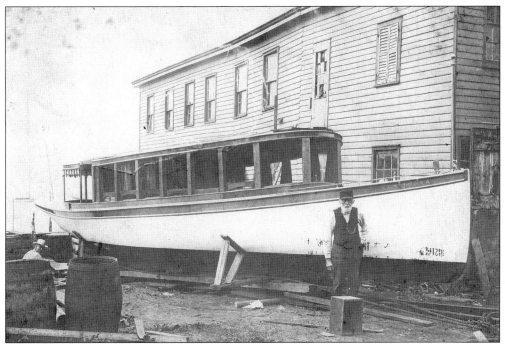

One of the waterfront businesses, John Brown's shipbuilding yard was located on West Main Street. This photograph of John Brown was taken in 1897.

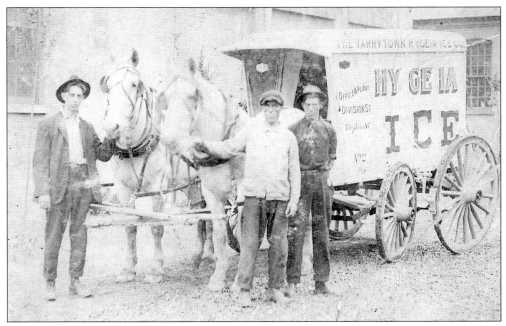

Clarence Brown purchased the Hygeia Ice Company, located on Division Street, from Richard Driscoll. He furnished the community with ice cut from Rockdale Lake at the end of Sheldon Avenue. The ice wagon, shown here, was a familiar sight along the village streets.

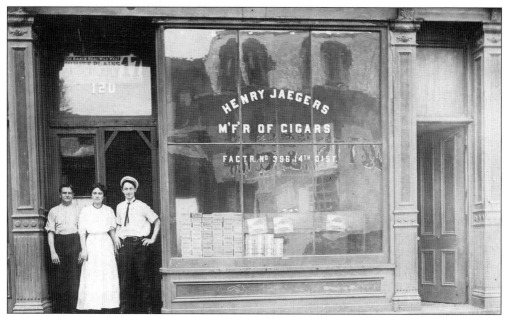

Located on Valley Street, Henry Jaegers' Cigar Shop was a popular stop for many residents. Shown here c. 1904 are, from left to right, Henry Jaegers, his sister, and William Davis. Many visitors to the shop remarked that "watching Bill Davis roll a Havana cigar was a work of art."

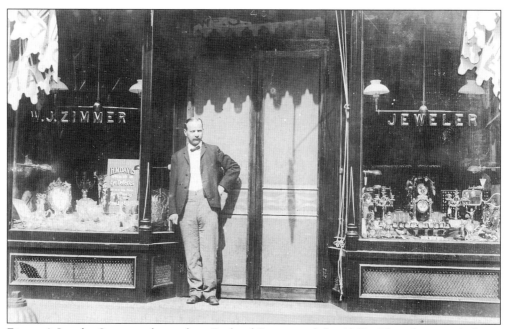

Zimmer's Jewelry Store was located on Orchard Street until the 1960s. This photograph shows Mr. Zimmer in front of his shop, c. 1912.

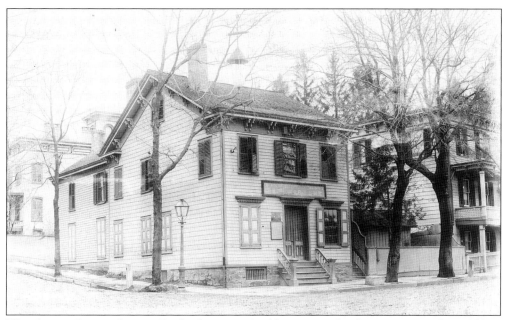

Westchester County Savings Bank, the county's oldest savings bank, was organized in 1853. It moved to the former Stephen York property in 1864. It was conveniently located at the main intersection of town, on the corner of Broadway and Main Street. Many old local families were among the incorporators of the organization, including Washington Irving and James Aston Webb, editor of the *New York Courier and Inquirer*

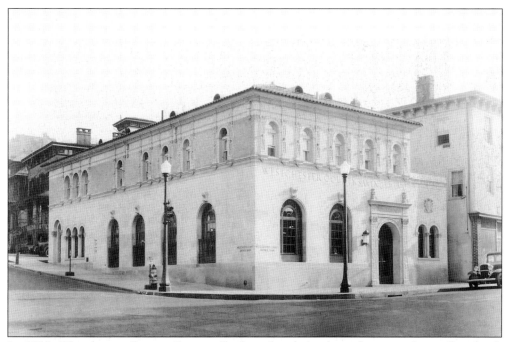

In 1898, Westchester County Savings Bank replaced the frame house with a yellow brick building in the Spanish Renaissance style. This building was expanded and modernized in 1933. The First Union National Bank currently occupies this historic space.

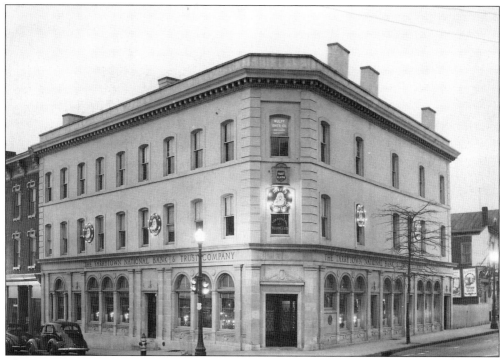

The Tarrytown National Bank was established in 1881 as a commercial bank by D.O. Bradley, Seth Bird, and Benson Ferris Jr., at a time when there were no commercial banking facilities in Tarrytown or the surrounding villages. The original bank was located at the southeast corner of Main and Orchard Streets and opened for business February 8, 1882. In October 1890, the bank moved to the northwest corner of Main and Orchard.

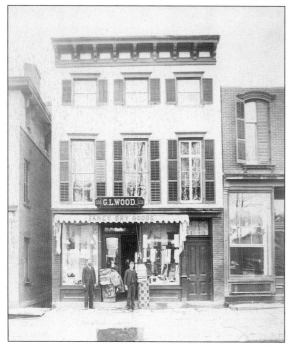

G.L. Wood's shop at 131 Main Street was once known as the "store that had everything." A milliner and fancy goods dealer, Wood is shown at left in the photograph.

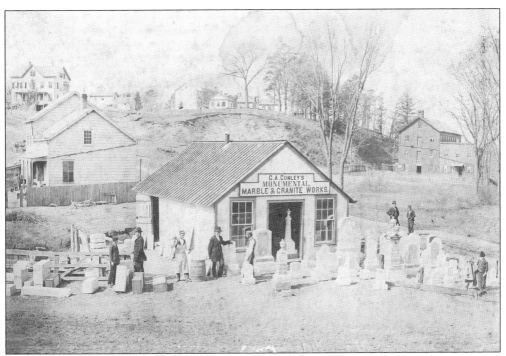

Established in 1872 by George A. Cunley on the corner of Broadway and Pocantico Street, Cunley's Marble Works produced stone monuments. Taking pride in creating original designs, the marble works created a variety of cemetery vaults, gravestones, and monuments for many residents of the community.

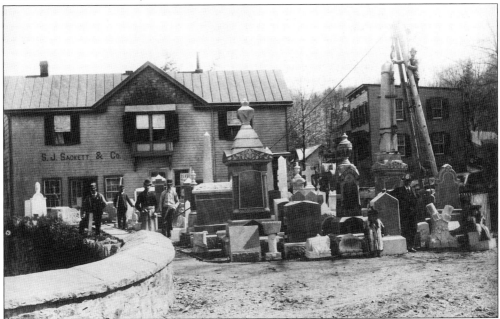

Located by the bridge overlooking the Pocantico River, Sackett's monuments was established before 1885 by S.J. Sackett. Advertisements from the 1880s indicate that Sackett also produced a variety of burial vaults and tombs, as well as stone entrance piers, walls, curbs, and copings.

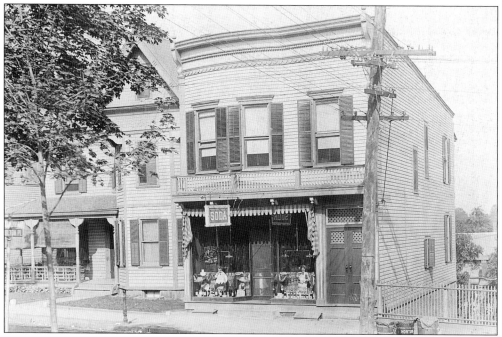

Charles H. Meirsch, an ice cream manufacturer, opened a small shop on the west side of Broadway opposite Hamilton Place. Photographed in 1917, Miersch's Soda Fountain was a popular stop for local children.

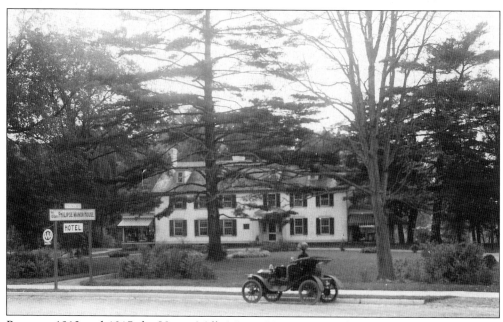

Between 1912 and 1917 the Upper Mills Manor House operated as a hotel. This photograph shows a small vehicle passing by at that time.

The Mott House, formerly located on Neperan Road, was constructed *c.* 1860 by Edward K. Mott. A fashionable hotel from the 1890s until 1914, the building had thirty-six rooms, a parlor, ladies room, reading room, electric lights, steam heat, and a telephone. After a brief stint as a boys school and Red Cross volunteer center, the building was purchased by Mr. Frame and turned into apartments prior to 1930.

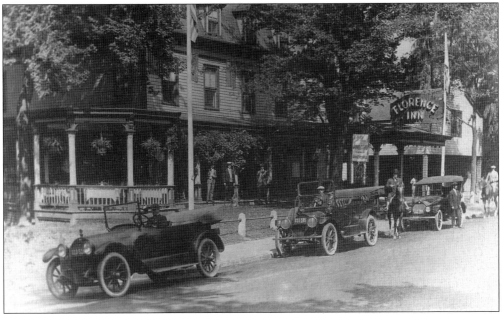

When it was established in 1821, the building on the corner of Broadway and Franklin Street was called the Franklin House. The name of the popular inn was changed to the Vincent House, and later the Florence Inn. Successful until after World War II, the inn had many distinguished guests including Washington Irving, Martin Van Buren, Rutherford B. Hayes, Teddy Roosevelt, and General William T. Sherman.

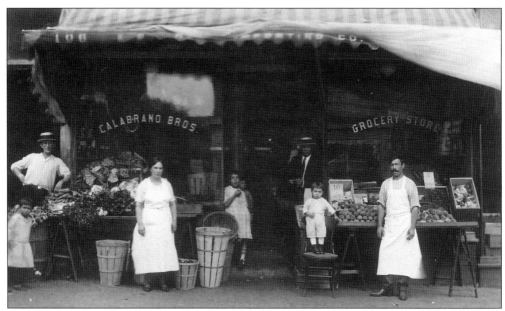

The Calabrano Brothers grocery was located on Cortlandt Street. Shown here are, from left to right, Lucy Calabrano, Lewis Calabrano, Camilla Calabrano, Jenny Calabrano, Natalie Calabrano, unknown, unknown, Tony Calabrano, and George Calabrano.

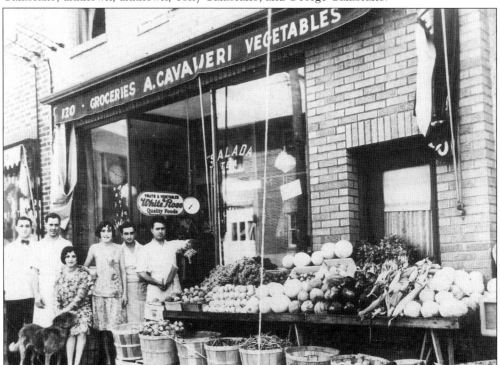

Established in 1913, Cavalieri's was a delight to all of the senses. Located on Cortlandt Street, the store owners delivered groceries all over the community. Shown here in 1929 are Max, Sande Schementi, Eleanor Schementi, Trixie (dog), Rose Cavalieri, John Cavalieri, and Joe Sansevera.

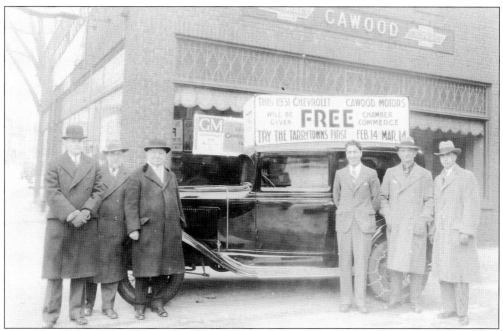

In 1931 the Chamber of Commerce held a raffle for a new Chevrolet. Shown are, from left to right, Wilbur Riker (secretary of the Chamber), Harry E. Cawood (Chevrolet dealer), Frank R. Pierson, Sal Chillemi, Fred V. Peters, and C.A. Cawood.

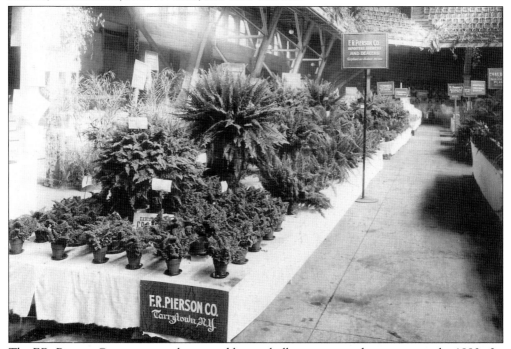

The F.R. Pierson Company was the second largest bulb importer in the country in the 1880s. Its final location was at the corner of North Broadway and McKeel Avenue (now the Bank of New York). Shown here is one of the company's fern exhibits. Mr. Pierson was an exhibitor at the Chicago World's Fair in 1893 and the Pan American Exposition in 1901.

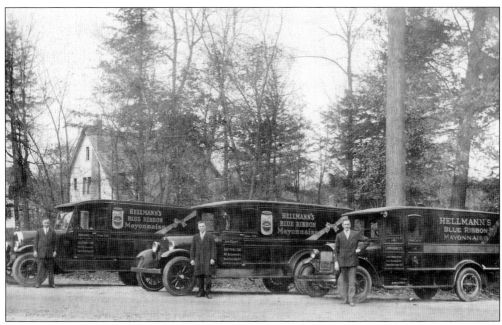

John Graniez owned a delicatessen at 90 Beekman Avenue until the 1960s. Graniez was also a distributor for Hellman's Mayonnaise. His fleet of trucks are shown above.

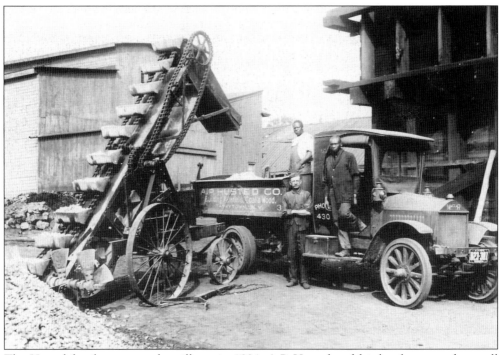

The Husted family came to the villages in 1884. A.P. Husted and his brother owned a small stretch of beach at the foot of Beekman Avenue by 1900. The brothers dealt in coal, wood, and other building materials. Pictured above are workers at their Depot Square location.

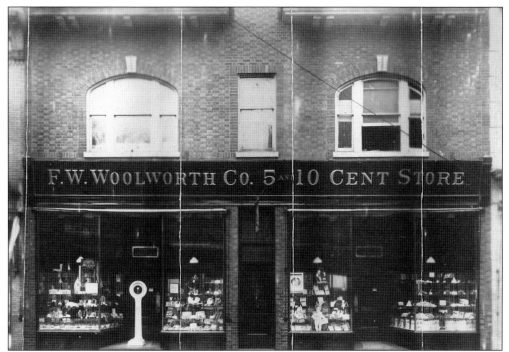

The F.W. Woolworth Company opened a store on Orchard Street in 1913. Pictured above, Woolworth's was full of a variety of useful household items. When the Orchard Street Store was razed in the 1960s, Woolworth's moved to 45 North Broadway. Although the store is no longer in town, many regulars fondly remember stopping in for a cup of coffee or a chat.

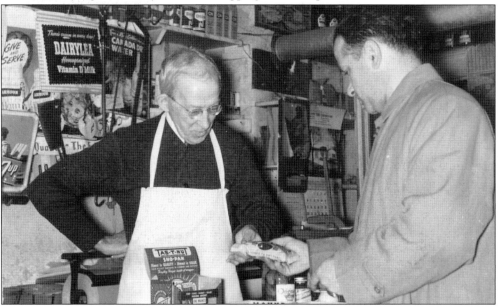

John Gross purchased a small store in the Pennybridge section of Tarrytown from Margaret Coyles in 1906. The store, originally operated by Thomas Purdy, was opened prior to 1866. The shop was filled with a variety of goods and edibles. Photographed in 1940, John Gross (left) ran the "Old Country Store" on Sheldon Avenue until the 1950s.

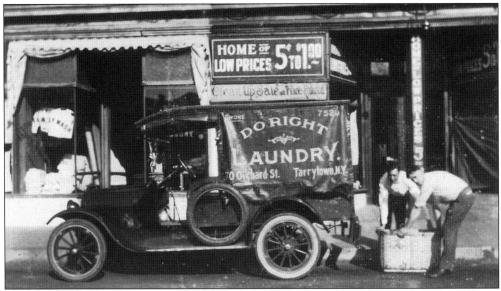

Orchard Street was a busy commercial district up until the 1960s. Delivery wagons, and later trucks, were a common sight along the roadway. This A.L. Trevillian photograph shows the Do Right Laundry truck near its 70 Orchard Street business.

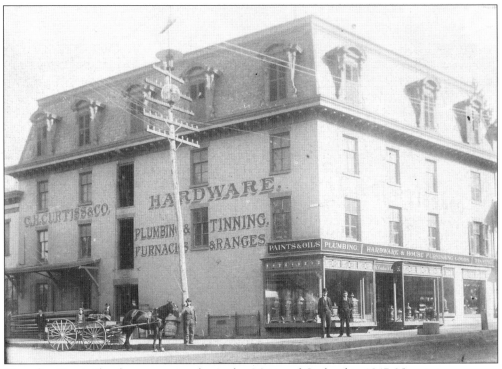

Cornelius Curtiss' hardware store was located at Main and Orchard in 1847. Now just a memory, this active street corner is shown in a c. 1890 photograph. Curtiss took on John Cramer as a partner in 1893, and their principal business was plumbing and steamfitting, as well as selling hardware and house furnishings.

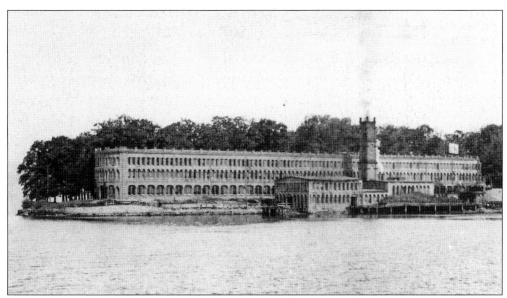

The automobile factory pictured here was designed by Stanford White and constructed on the Kingsland property on lower Beekman Avenue, North Tarrytown, in 1899. The 700-window brick-and-steel factory had an unconventional square chimney and a large clock. The 300-by-50-foot building was three stories high. It was used by the Mobile Company of America (1900–1903), the Maxwell-Briscoe Motor Company (1904–1913) and, by 1915, the Chevrolet Motor Company.

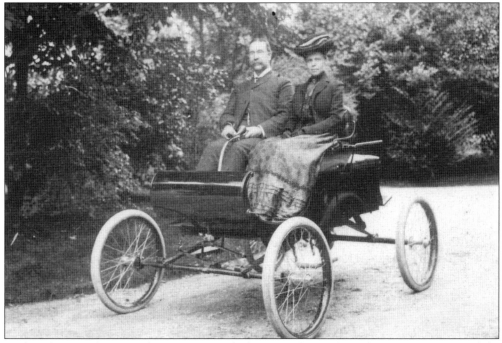

In this photograph, Mr. and Mrs. H.W. Nichols are out for a ride in their Steamer automobile. Walker Steamers were manufactured in North Tarrytown by John Brisben Walker. The cars could travel up to 40 mph and cost $650.

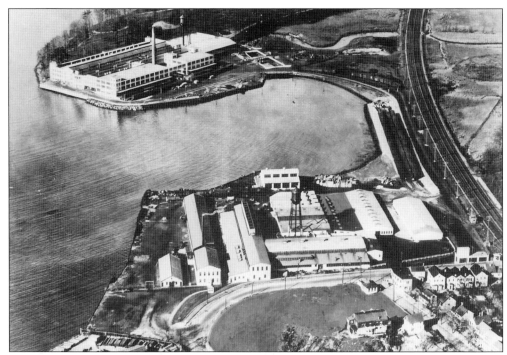

This map shows the Tarrytown plant as it appeared in 1925. At the top left, Fisher Body, which opened in 1925, shared the three-story building with Chevrolet. In 1926 it became a part of General Motors. The new buildings in the foreground were added in 1919.

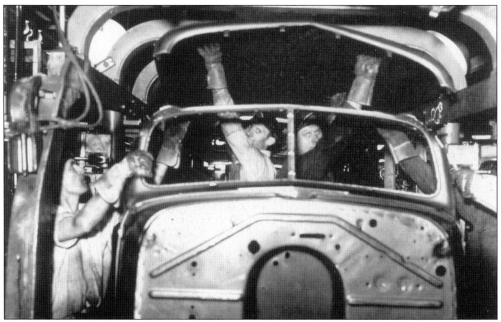

Car bodies manufactured at the Fisher Body plant were sent to General Motors for assembly. This photograph, c. 1930s, shows a pre-automation assembly line, with four men installing the roof on a car. The two-sided front windshields, shown in this photograph, evolved after 1936.

Seven

School Days

Both villages have always been homes to a number of public and private institutions of learning. Prior to the consolidation of the school system in the 1950s, each village had separate public schools that played a vital role in community identity. In fact, the rivalry, especially between the two high schools, was legendary. The photographs in this chapter tell the story of school days long gone.

While there has been some debate over the exact date that the Sleepy Hollow Free School was established, historians agree that in 1865 the first schoolhouse was torn down and the new larger structure, shown here, was built. Located on Sleepy Hollow Road, this building was used until the 1890s.

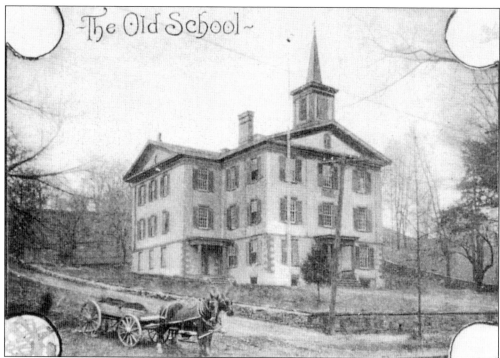

At his own expense, Captain Nathan Cobb constructed a two-story school on the corner of East Franklin Street and South Broadway for the village of Tarrytown in 1851. The Cobb school served the village until the 1890s. In 1891 an explosion three quarters of a mile away cracked the walls and foundation of the building. The school continued to be utilized until 1897 when the construction of a new and larger building was completed.

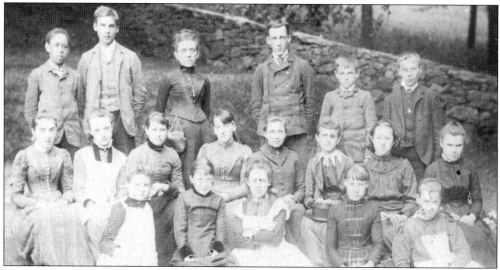

These Cobb School students in 1890 are, from left to right, as follows: (front row) Grace Muller, Kitty Brewer, unknown, Grace White, and Lou McKay; (second row) Edna Travis, unknown, Belle Odell, Belle Travis, Frances Moore, Lottie Henderson, Lucille Townsend, and Adele Johnson; (back row) ? Kingsland, unknown, Miss Clothier (teacher), unknown, Tess Bird, and unknown.

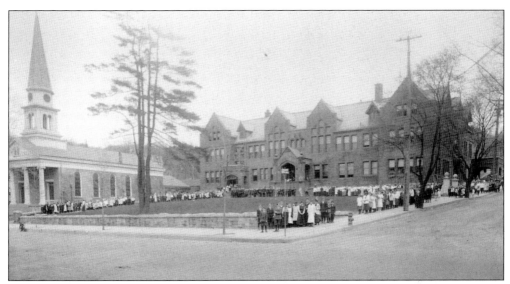

After the Cobb school was damaged, the first step toward establishing a new school was the purchase of the Mott and Howell properties at North Broadway and Hamilton Place. The cornerstone for the Elizabethan-style Washington Irving High School was laid on June 25, 1897, and the first graduate was Frank Vanderbilt in 1898. Designated a landmark, the building is shown with the students participating in a fire drill.

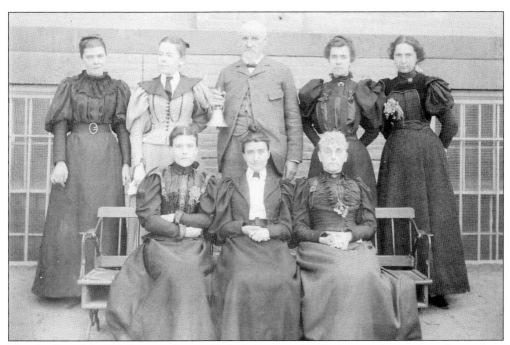

The faculty of the Washington Irving High School, c. 1899. Among the teachers shown here are Miss Harriet Lavender, Miss Emma Silver, and Mr. Nathan Hilton Dumond.

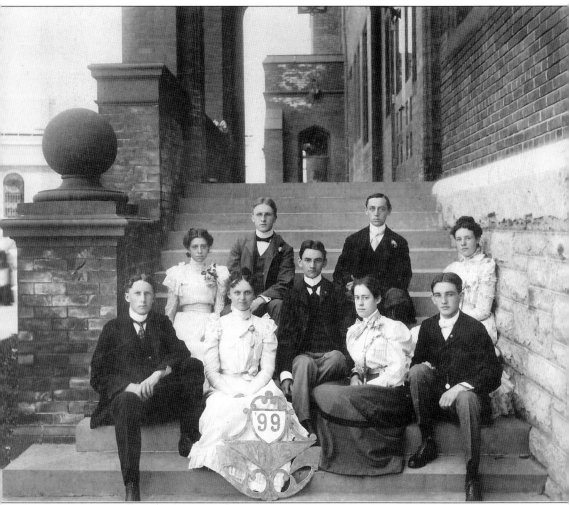

Members of the Washington Irving High School Class of 1899 shown in this photograph are, from left to right, as follows: (front row) Fred McCutchen, Mary Platt, Clara Mowery, and Lester Crocker; (second row) Louise Bird, Fred Briggs, and Ethel Leonard; (back row) William MacBean and Charles Fairchild.

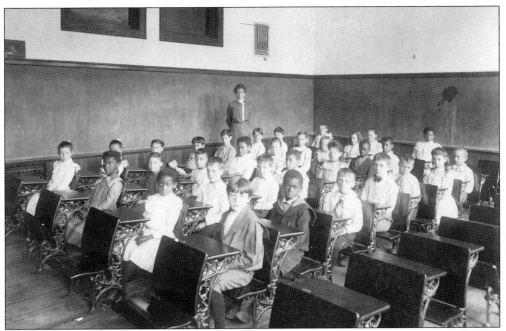

A typical classroom at the Washington Irving School shows the second grade class in the spring of 1902.

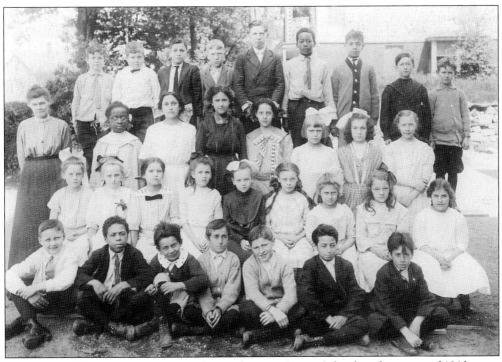

Miss Lavender's fourth grade class at the Washington Irving School in the spring of 1913.

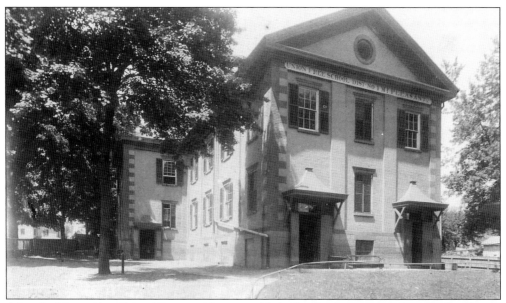

After the Union Free School District 12 was established in Beekmantown, a small schoolhouse was constructed on Depeyster Street. Soon outgrowing this building, as well as a second structure, the people of the village had a larger school built on Beekman Avenue. Shown above, the North Tarrytown Public School was dedicated in 1860. After 1895, when New York required children to attend school, another larger school was needed and this building was torn down.

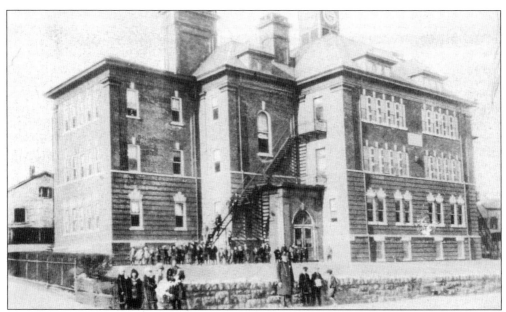

The North Tarrytown High School was constructed on Beekman Avenue in 1899. The school contained an assembly hall, nineteen classrooms, a board room, a library, and a large stage with seating for 800. An electric time system rang bells for each class period and a large clock, donated by Helen Gould, was placed in the school's tower. When a new high school was built in 1922, this building became the North Tarrytown Elementary school.

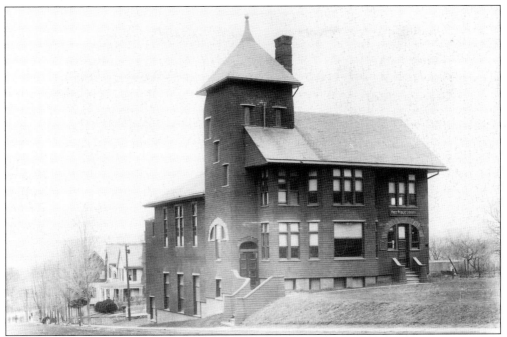

Organized as a reading and debating club, the Young Men's Lyceum is the oldest organization in the villages. In 1881 the building, shown here in an 1897 photograph, was constructed on Central Avenue in Tarrytown. For a time the Lyceum housed a public library and the first public kindergarten classes. After a fire in 1929, a new building was constructed to the east of the original Lyceum.

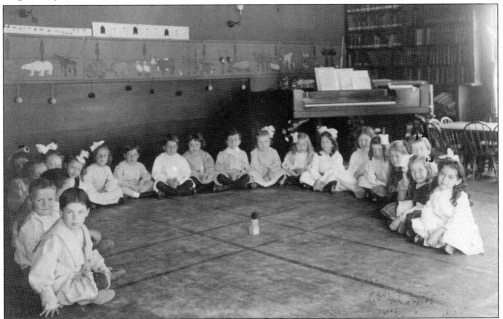

During the early twentieth century the Washington Irving School housed students from grades one through twelve. Public kindergarten classes were held in the nearby Lyceum building. The photograph above, and the cover photograph, show two of these classes at play.

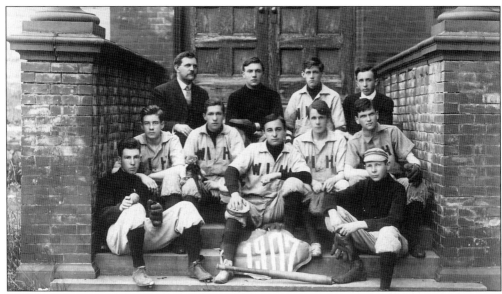

The 1907 championship baseball team from Washington Irving High School is shown here. From left to right are as follows: (front row) Abe Sadofsky, pitcher; James R. Losee, captain and third baseman; and Roy Minnerly, right fielder; (second row) Ralph Todd, left fielder; Fred Morse, second baseman; Lee Rice, shortstop; and Bayard Allen, center fielder; (back row) Leslie V. Case, coach;, Fred Croke, first baseman; Steve Richards, catcher;, and Dick Wright, manager.

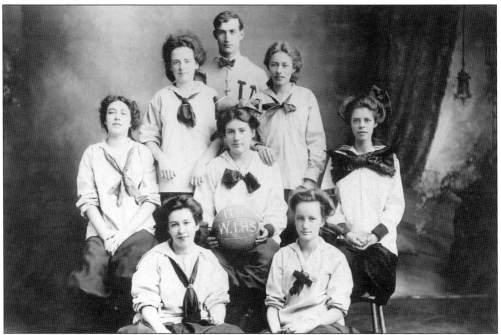

The first girls basketball team at Washington Irving High School formed in 1911. From left to right are as follows: (front row) Dorothy Wright and Leah Curtiss; (second row) Ruth Hart, Isabell Duell, captain, and Ruth McElravy; (third row) Marion Whyte and Eleanor Suydam; (back) Mr. Haygar, the team coach.

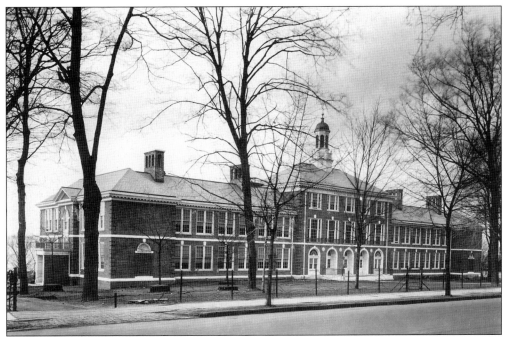

During the 1920s overcrowding became a problem at the Washington Irving High School and a new building was needed. Washington Irving was renamed for Frank R. Pierson and used for elementary classes, and a new school building was constructed on the west side of Broadway across the street from the site of the former Cobb School. The new Washington Irving High School opened in September 1925.

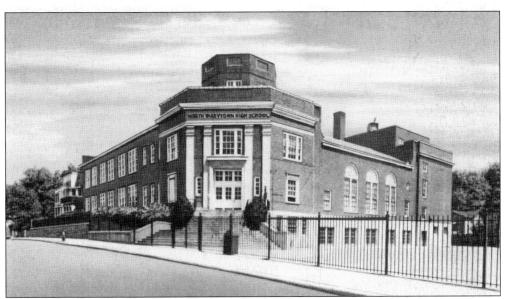

The cornerstone for the new North Tarrytown High School was laid in 1922 on Pocantico Street. Built behind the older high school, which was now used as an elementary school, the new high school had a dedicated student body that soon became involved in a variety of social, political, and athletic extra-curricular activities.

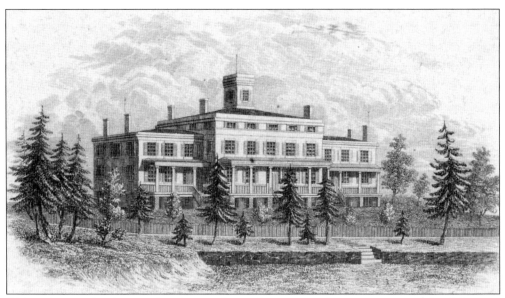

Although many families employed tutors during the nineteenth century, private schools became increasingly more popular. Founded in 1837 by William and Charles Lyons, the Irving Institute was the first recorded private school in the community. Located on Pocantico Street until 1904, the main house was moved to the Wallace property just south of the First Reformed Church on North Broadway. The Irving School, as it was later called, was a fashionable boarding school for boys until 1955.

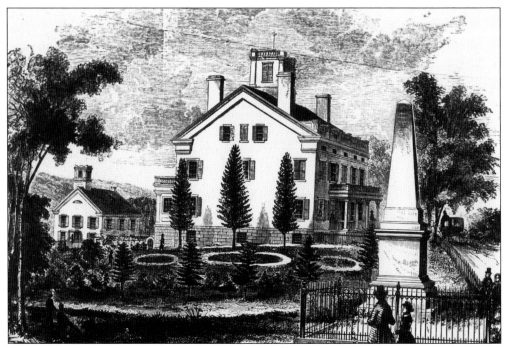

Although short-lived, the Tarrytown Institute was a popular boarding school for boys during the nineteenth century. Operated by Mr. A. Newman, the school was established in 1867 and stood west of the Captors' Monument on Washington Street.

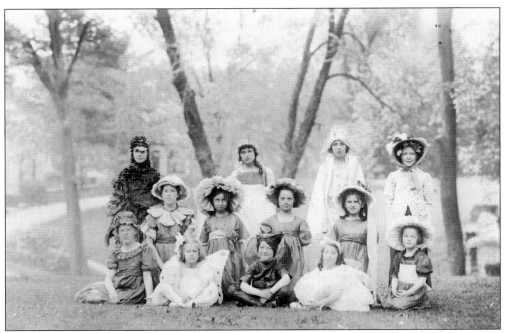

Started in Briarcliff Manor, the Knox School moved to Brookside Park (Patriots Park) after a fire destroyed the school building in 1909. A boarding school for young girls, the Knox School eventually outgrew this location and moved to Cooperstown in 1918.

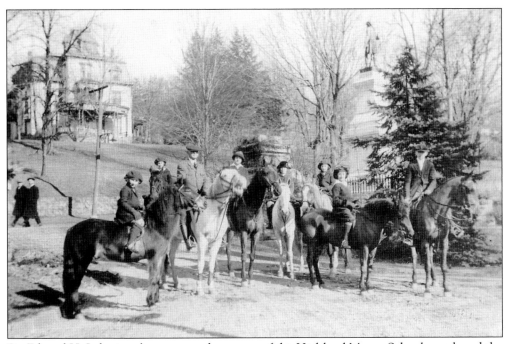

Dr. Edward H. Lehman, the owner and operator of the Highland Manor School, purchased the Knox school complex in 1919. The progressive non-sectarian school was located between the two villages until 1941, when it was moved to New Jersey. This photograph by A. Trevillian shows several students on horseback in 1922.

Located on College Avenue, the Home Institute, also known as Miss Metcalf's school, was founded in the early 1860s. Operated by the Misses Mildred and Helen Metcalf, the school flourished until World War I.

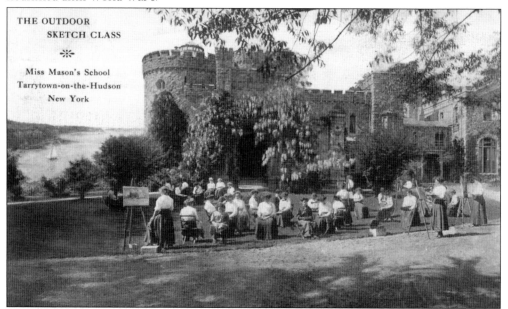

THE OUTDOOR
SKETCH CLASS

Miss Mason's School
Tarrytown-on-the-Hudson
New York

One of the more prestigious boarding schools was Miss Mason's Castle School. In 1895 Miss Cassity Mason relocated her exclusive Eastman School to the Herrick estate in Tarrytown. Advertised as a post-finishing school for young women, the Castle school offered a well-rounded education for both American and foreign students. When Miss Mason died in 1933 the school closed and the building was demolished in 1944.

Military boarding schools became popular in the nineteenth century, and several of these schools, including Newman's Military Academy, Starr's Military Institute, and the Jackson Military Institute, found a home in the community. It was not uncommon to travel down Beekman Avenue and see the students on the parade grounds on the west side of Pocantico Street where the Van Tassel Apartments were later constructed.

Operated by Franciscan nuns, the oldest parochial school in the villages, St. Theresa's School, opened for young girls in 1885. Originally located in a hall adjacent to the church on Depeyster Street, the school later became coeducational. During the 1920s a larger school facility was built. At one time, the school had bowling alleys constructed when the sport became popular.

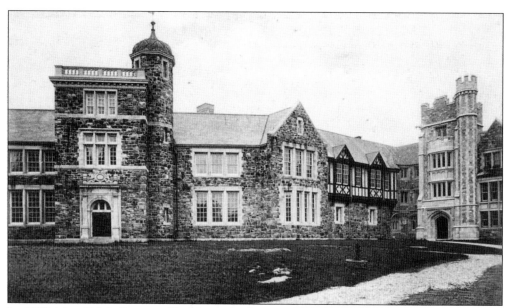

In 1899 Mrs. Caleb Brewster Hackley helped to establish a liberal boys boarding school in Tarrytown at her estate on Castle Ridge, near Benedict Avenue. During the first decade of the twentieth century the adjoining Andrews estate was purchased and several large masonry structures were built to house the growing student population. Hackley School quickly became well known as one of the better prep schools in the Northeast.

Marymount Academy was established by Mother Marie Joseph Butler on land donated by her cousin, James Butler, in 1907. Located on the corner of McKeel and Neperan Avenues, the school for young women later became Marymount College. Additional property was purchased and the campus enlarged, filling the landscape between Neperan Road and Union Avenue, and overlooking the Hudson. Conducted by the Religious Order of the Sacred Heart of Mary, Marymount became one of the leading Catholic colleges for women in the United States.

Eight

The River

Located on the eastern shore of the Hudson River, Tarrytown and Sleepy Hollow enjoy the same river views so revered by the romantic painters of the nineteenth century. Over the years the river has offered pleasure, recreation, commerce, and transportation to the people who came to live, work, and build homes along its shores.

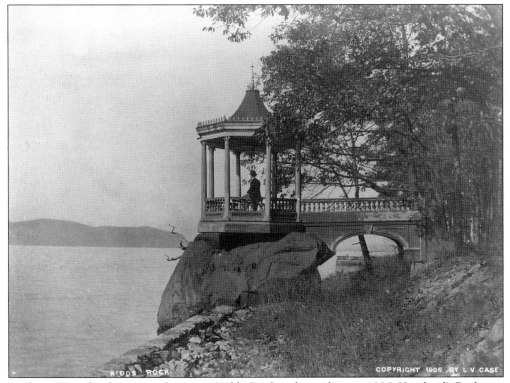

Ambrose Kingsland's summer house on Kidd's Rock is shown here *c*. 1906. Kingland's Beekman Point estate was later developed as Philipse Manor. Kidd's Rock was named for Captain Kidd, the infamous pirate who, according to local legend, traded with Frederick Philipse.

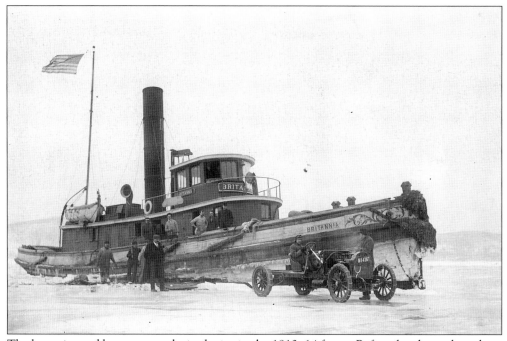

The boat pictured here was caught in the ice in the 1913–14 freeze. Before the channel was kept clear by ice cutters, the Hudson River regularly froze over during the winter and pedestrians were able to walk across to Nyack and back to Tarrytown in one day.

This view of the Hudson River, busy with commercial and recreational vessels, shows Odell's Coal, Lumber, Feed, and Building Materials Company in the background. The Odell family's Coal and Lumber Company was located at the foot of Main Street and Steamboat Dock until the early 1900s.

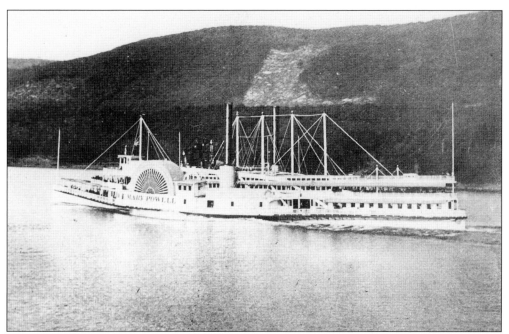

The Hudson River steamboat *Mary Powell*, the undisputed Queen of the Hudson, was for many years the fastest boat on the river. Launched in 1861 under the flag of the Hudson River Steamboat Line (which later became the Hudson River Dayline), the *Mary Powell* was known for her beauty, elegance, and the lack of frivolous trappings that might have decreased her speed. She remained in service until 1918.

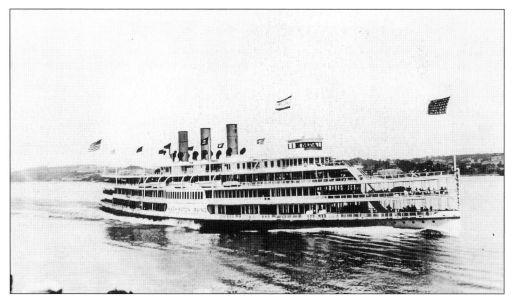

The *Washington Irving*, at over 400 feet long, was the largest steamboat in the Hudson River Dayline. Launched in 1922, it boasted the finest art gallery on the river with scenes of the Alhambra and England's Bracebridge Hall , as well as a series of Hudson River paintings and pictures of old New York. In service for only four years, it was struck by a barge in 1926 and sank.

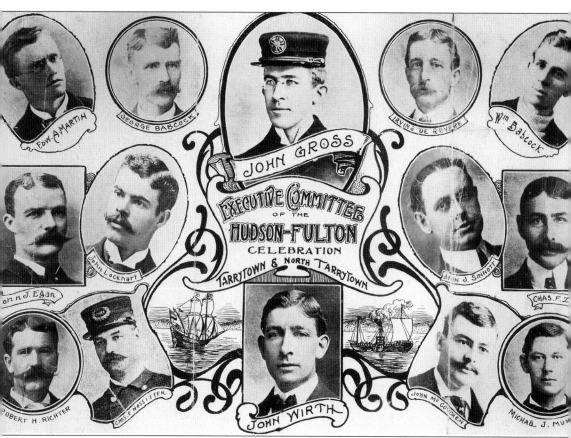

The greatest cooperative venture for Tarrytown and North Tarrytown was the week-long Hudson-Fulton Celebration, held September 25 through October 29, 1909. The event was headed by John Gross and John Wirth, presidents of Tarrytown and North Tarrytown. Hudson River towns celebrated Henry Hudson's historic 1609 voyage and Robert Fulton's successful launching of his steamboat in 1807 with a great river parade that included 1,542 ships. The entire U.S. Atlantic fleet, replicas of the *Half Moon* and the *Clermont*, as well as ships from other nations, sailed up the Hudson during the celebration. The Tarrytowns' parade (see page 106), an extravaganza of fire companies, marching bands, organizations, and historical floats, ended at Depot Square with a magnificent display of fireworks. Riverside Hose held a ball at the Music Hall and General Howard Carroll entertained officers and members of the German Fleet at Carrollcliff.

During the winter, sports were sleigh riding and skating on lakes, ponds, and even the river. It was necessary to light fires at night in order to see and keep warm. "I can't remember the cold ever keeping us inside," wrote Ernest Conover in his reminiscences.

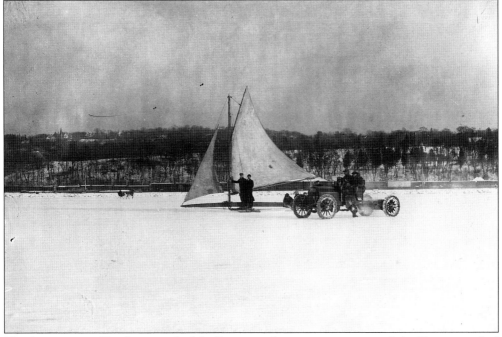

The frozen river offered a myriad of challenges to the true sportsman, and the Tarrytowns had their share of intrepid racers. Iceboating and automobile racing were very popular. In 1918, Otto Boock once sped across the river in his ice boat in less than three minutes, according to local lore.

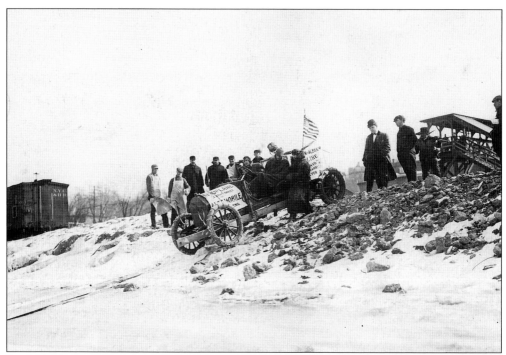

Fred Koenig launched his Mercedes on the ice for the "Most Sensational Race Ever"—an aeroplane vs. automobile race—on Saturday, February 10, 1912. He was no match for Clifton Hadley's plane, however, which easily passed the car at the very beginning of the race.

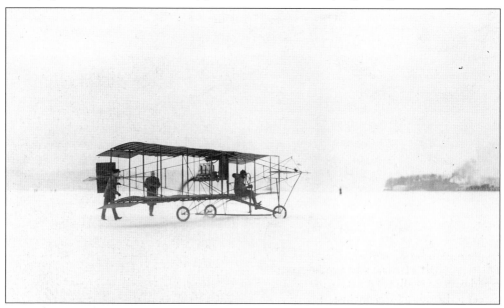

Around 1910, Clifton O. Hadley built an airplane in the Steurer and Hadley warehouse and took it to Long Island to test it . In 1912 he tried to break the world's duration record, but was forced to stop after 185 miles when an unknown huntsman perforated one cylinder of his Roberts Motor. In Fred Koenig's automobile challenge, Hadley entertained the crowds by taking off from the frozen Hudson. He was the first person from this area ever to fly from the ice.

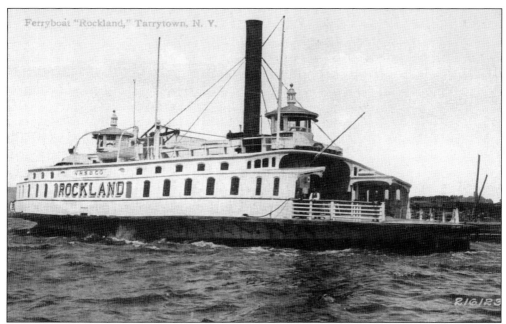

The *Rockland*, called the most colorful ferry on the Tarrytown/Nyack run, operated longer than any other ferry. Launched May 9, 1888, it sailed until 1926. Commuters enjoyed a peaceful ride until around 1912, when a rival company launched their own ferry. Each ferryboat tried to steal fares from the other as they raced across the river, cutting each other off whenever possible. The "wars" subsided when the rival steamboat rammed the *Rockland* in frustration.

Captain John Lyon, master of the *Rockland*, was not very tall, but he had a powerful voice that could be heard calling "All Aboard" from Bird Street to Broadway. Originally from Scotland, Captain Lyon was on the river for seventy-one years, becoming a captain in his twenties. The *Rockland* was his ferry and he ran it as though he owned it until his death in 1923. The *Rockland* continued for three more years.

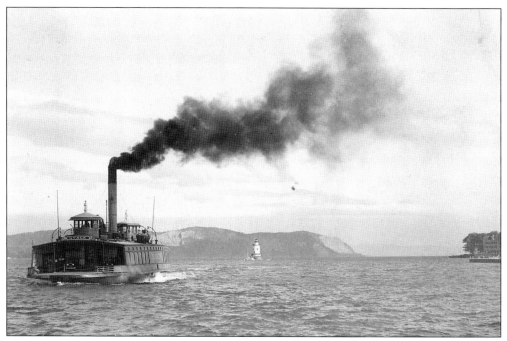

Ferry service began on the river in 1839 and cost only 5¢ a ride at the turn of the century. The *Nyack*, shown here, was one of the last ferries of the era. It continued on the river until 1941, when it became unprofitable. Pedestrian ferries operated until the building of the Tappan Zee Bridge in the 1950s.

The Tarrytown Ferry Dock served commuters to Rockland County as well as those traveling by steamer to New York City. While waiting for the ferry, passengers could walk over to Fred Boock's hotel and beer garden located near the dock for drinks, sandwiches, and other snacks.

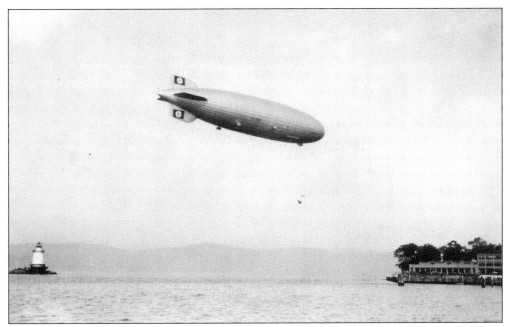

On October 9, 1936, the German dirigible *Hindenburg* sent the following radiogram: "Very new and young Hindenburg, salutes very old and storied Tarrytown, extending felicitations to Irving School on 100th anniversary." The *Hindenburg* made several flights over the Atlantic until the tragedy on May 6, 1937, in Lakehurst, New Jersey, where it burst into flames, killing thirty-six of the ninety-seven people on board.

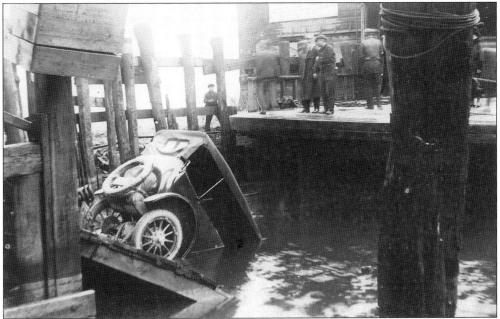

Alfred L. Trevellian had the following to say about this picture: "Did you ever see a mobile take a dive in the river? Well! Here is a picture of one I took Sunday morning December 15, 1918 and it was an awful foggy morning. The boat (Flushing), had drifted a little out and when the mobile got on the gangplank it went down and the boat wasn't under it to stop it . . ."

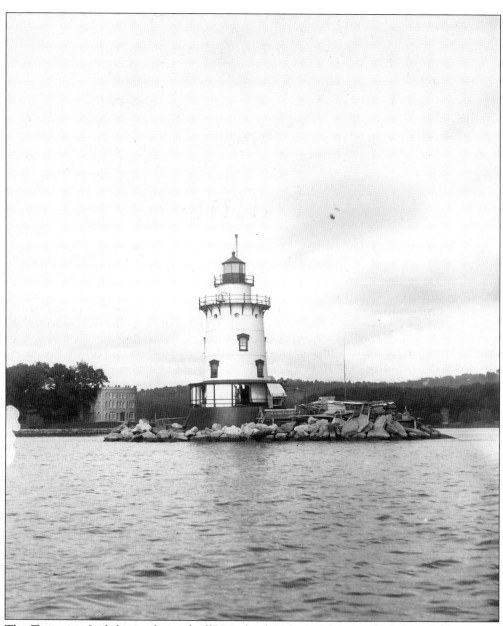

The Tarrytown Lighthouse, located off Kingsland Point in what was then North Tarrytown, was built in 1883 at a cost of $20,795. Jacob Ackerman, lighthouse keeper from 1883 to 1904, wrote in his October 1, 1883 journal "New light established and lighted for the first time and all worked well." The cast-iron pier was painted red, the tower white, and the lantern black. A fixed white light was visible for 13 nautical miles. In addition, a mechanical bell sounded every 20 seconds. Ackerman's journal at the lighthouse contains accounts of terrible storms and daring rescues. About a quarter mile separated the structure from the southerly tip of Kingsland Point, the nearest land. The lighthouse keeper's family rowed back and forth with provisions for their little round homestead. In the winter, the family would walk over the frozen river to the shore and back. The lighthouse, now on the National Register of Historic Places, was decommissioned in 1965.

Nine

Trains

The quiet and rural life of the villages was altered forever by the arrival of the railroad in 1849. This diverted passengers from the steamships to the trains and hastened the end of the stagecoach. It caused an increase in industry and commerce, provided easy access to New York City, and led to the development and growth of Tarrytown and what is now Sleepy Hollow. At the turn of the century, six railroad stations and two railroad companies served the villages of Tarrytown, North Tarrytown, and Pocantico Hills.

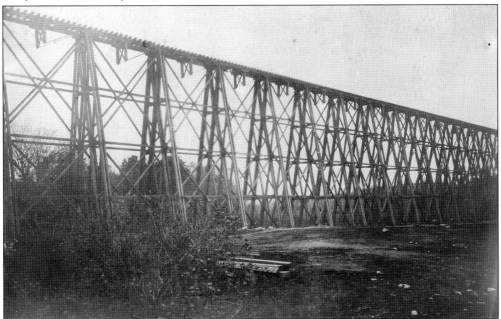

The railroad trestle, one track wide, 80 feet from the ground, and constructed of timber, bridged an area near the Tarrytown Lakes. The first train rumbled over the trestle, terrifying passengers and spectators in December of 1880. "More suggestive of broken bones than safety," according to Sharf's *History of Westchester County*, the trestle was in service less than a year, and a new route was built through Pocantico Hills by November of 1881.

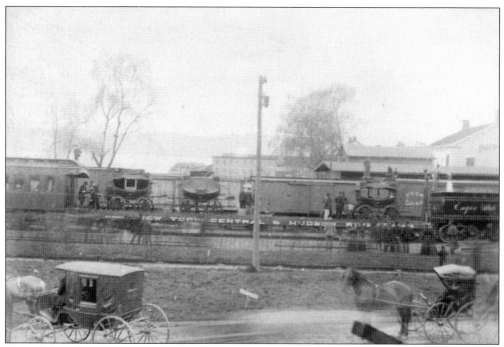

The Hudson River Railroad, vital to industry and commuters, began hauling passengers and freight in 1849. One of the trains is shown here with a load of carriages. Later automobiles from the General Motors plant in North Tarrytown were transported over the rails.

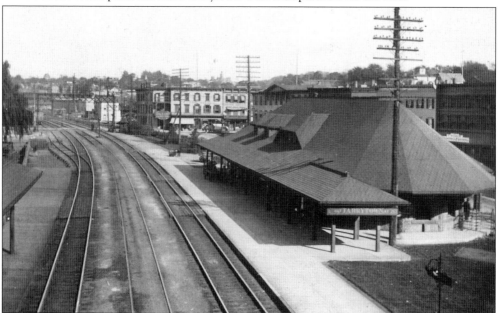

This is an early image of the Tarrytown Railroad Station. Seth Bird erected the first railroad station just north of the current building and later built a bigger depot which opened for business in 1870. The present depot was built in 1890 from Massachusetts granite and red sandstone. Many residents who had been commuting by river steamer switched to rail, paying about $106 for a yearly ticket.

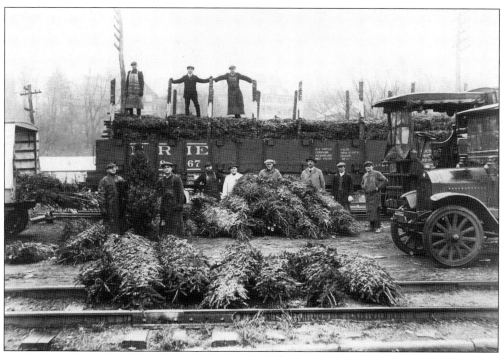

Around the turn of the century the New York Central filled in the cove and created a 30-acre freight yard. Christmas trees are being unloaded in the yard in this December, 1920 photograph by A.L. Trevillian.

Fountains were erected in the nineteenth century to provide water for thirsty horses, cats, dogs, and pedestrians. In 1881, Tarrytown had four fountains, all donated by wealthy citizens. Located in Depot Square, this three-level, bronze-coated iron structure stood in a miniature pool with water lilies and plants. It was donated by the Reverend Edward C. Bull.

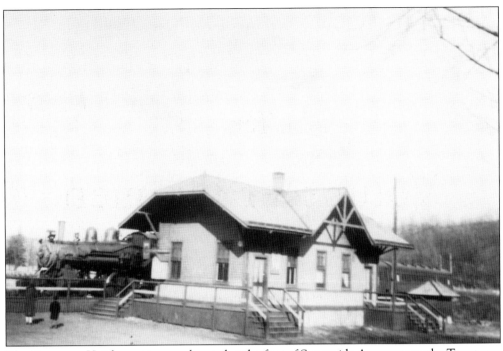

The Tarrytown Heights station was located at the foot of Sunnyside Avenue near the Tarrytown Lakes. Around 1930, the Rockefeller interests began purchasing almost all of Eastview and relocated the road bed and track so that the Putnam Division trains no longer passed through the Pocantico estate, thereby eliminating the Tarrytown Heights, Tower Hill, and Pocantico Hills stations.

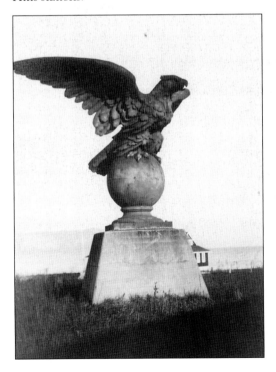

The Philipse Manor Eagle is one of twenty-two cast-iron eagles that once perched on top of the old Grand Central Terminal in New York City. The Philipse Manor Land Company, early developers of Philipse Manor, petitioned the New York Central railroad for a station at the new development. A station was erected and the eagle was placed west of the building around 1915.

Ten

Volunteer Firemen

The disastrous fires in 1869 and 1876, fought with the old method of wet blankets and bucket brigades, caused concerned citizens in Tarrytown and North Tarrytown to consider organizing to fight fires. In May of 1876, Fire Patrol No. 1, North Tarrytown's first fire company, was organized to control looting at fire scenes. In November of the same year, Hope Hose Co. No. 1 was formed in Tarrytown. By 1909 the residents of both villages could count on twelve volunteer companies. The firemen who performed this vital service also contributed some of the most enjoyable events such as huge parades and celebrations featuring local and out-of-town companies and marching bands.

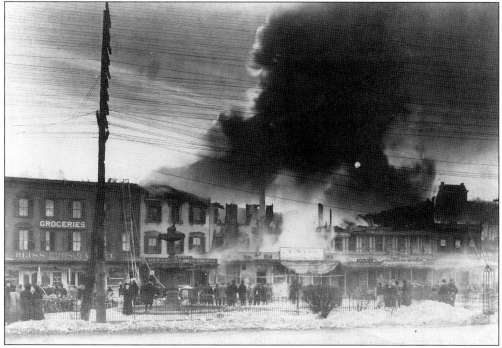

The Depot Square Fire broke out on February 25, 1907, and nearly leveled the Depot Plaza section of Tarrytown. Damages were estimated at $250,000. Lack of water was the reason given for the fire's terrifying speed. Fire companies from nearby towns were called for help and White Plains was able to respond the fastest by placing hose equipment on a trolley that ran straight to the Tarrytown depot. This photograph was taken by A.L. Trevillian.

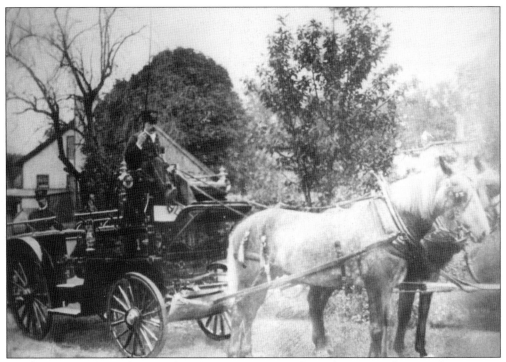

Fire Patrol, North Tarrytown's first fire company, was formed in May of 1876 when twenty merchants became concerned about looting at fire scenes. This 1880 photograph shows what was probably North Tarrytown's first fire apparatus.

Conqueror Hook and Ladder, Tarrytown (organized in 1860 and again in 1877), is shown here in the joint Firemen's Inspection Parade of 1912 in front of the First Baptist Church's "Beaux Arts Parsonage." O.J. Lyon is driving and Edward S. Yocum is at the tiller.

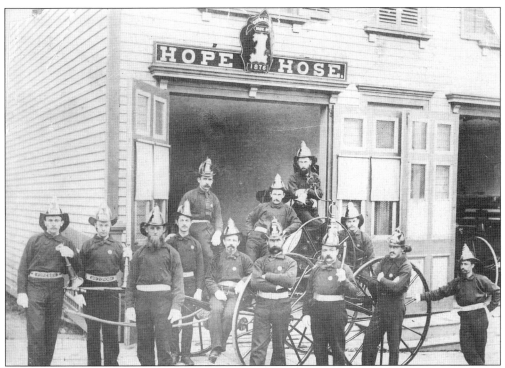

Hope Hose, Tarrytown, organized in 1876, is ready to march in the first firemen's parade in September 1881. Most fire equipment was hand pulled until the turn of the century, when horses began to provide pulling power. Hope Hose was organized as a result of the 1876 Orchard Street Fire, which gutted nineteen buildings.

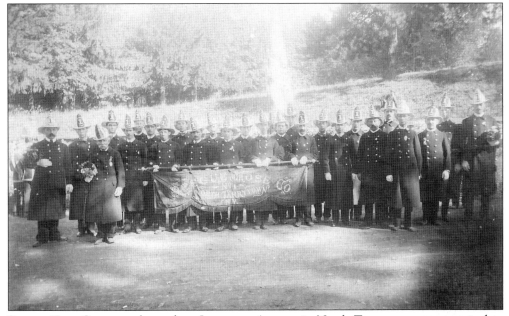

Rescue Hose Company, located on Lawrence Avenue in North Tarrytown, was organized in 1887. The company is shown here about 1890 assembled for a parade.

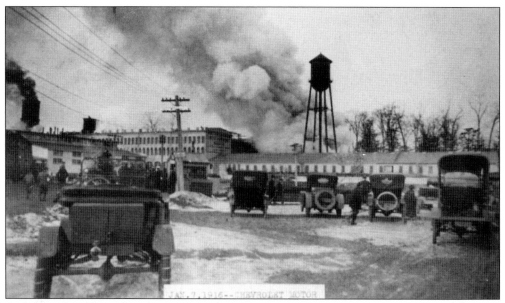

A fire at the Chevrolet plant occurred on January 7, 1916. The first recorded fire at the automobile plant was October 9, 1911, when only three cars were destroyed. The more serious fire shown here destroyed 500 motors. The fire, which was thought to be the result of spontaneous combustion, caused a loss of $20,000.

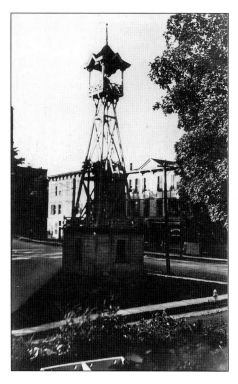

The old tower and fire bell on Washington and Valley Streets, North Tarrytown, was completed in 1892. At the time the bell was installed, one of the few area telephones was in the home of Michael J. Martin on Chestnut Street, a short distance from the bell tower. A great many fire calls were received at his home. Often, Mrs. Martin would run to the tower and ring the bell herself. This bell was the only means of sounding an alarm until 1912.

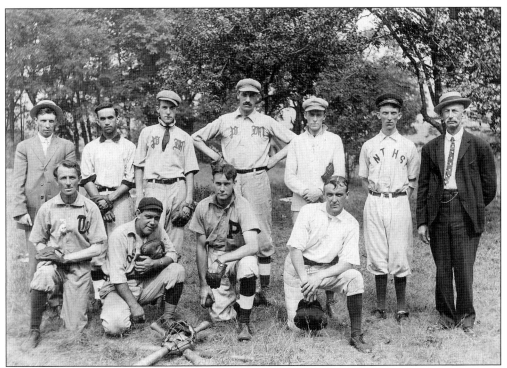

The Rescue Hose baseball team, c. 1910, is pictured here. The fire companies, which had begun as groups of men offering a needed service to the community, developed into closely knit organizations which provided social activities including parades, outings, and team sports.

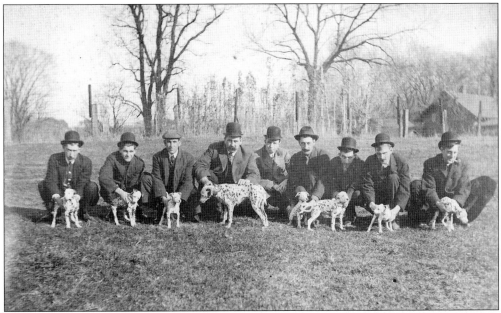

Dalmatians are traditional fire company mascots and, in 1908, Hope Hose's own had a litter of seven puppies. Members of the company and all eight dogs are proudly assembled for this photograph.

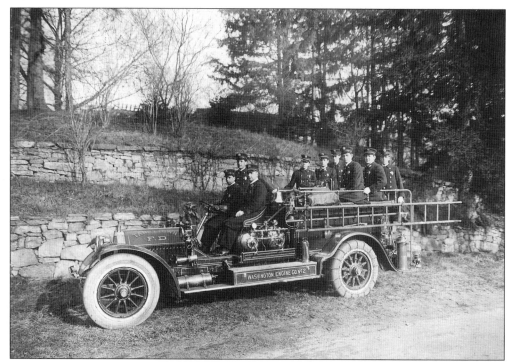

Washington Engine Company, Tarrytown, was the first company to acquire a motorized truck. They purchased this Locomobile on October 24, 1911. Other fire companies followed close behind, and by the end of World War I all companies in both villages were motorized.

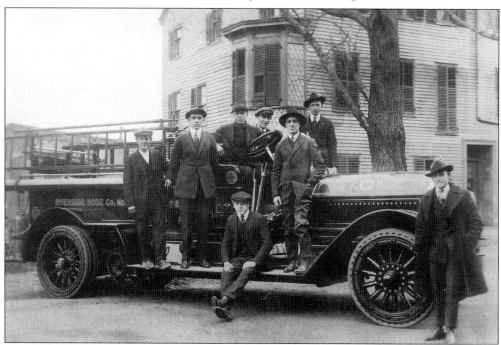

Riverside Hose Company of Tarrytown was organized in 1900. Members are shown here in a 1920 photograph taken by A.L. Trevillian.

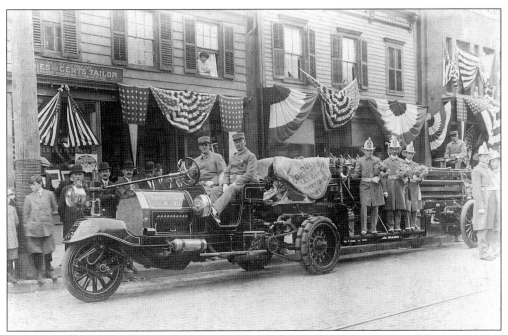

Conqueror Hook & Ladder Company purchased a three-wheel Knox Martin tractor in 1912, thereby replacing three horses. The driver in this picture was Hovey Hill and seated next to him was Chief of Police Nossiter.

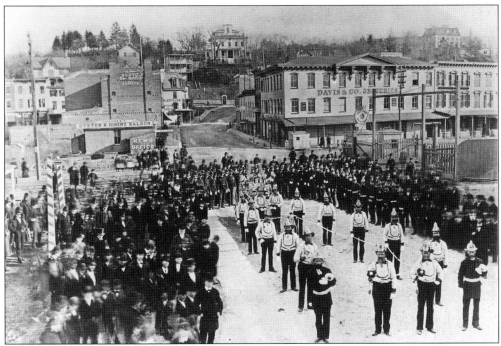

This photograph of Main Street and Orchard Street is dated about 1878, a year after Pheonix Hose Company of Tarrytown, shown in the foreground, was admitted to the group. Firemen held their first joint village parade in 1881 and continued the tradition every October for about forty years.

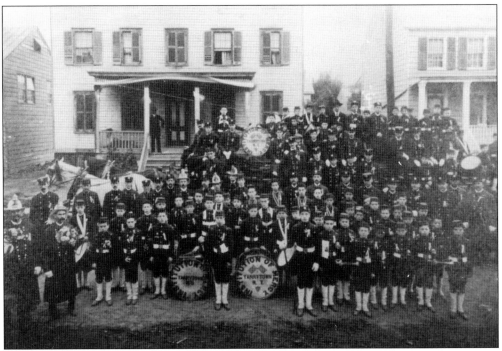

Children from the Institute of Mercy, an orphanage located in Tarrytown, are pictured here with members of Pocantico Hook & Ladder Company, October 11, 1905.

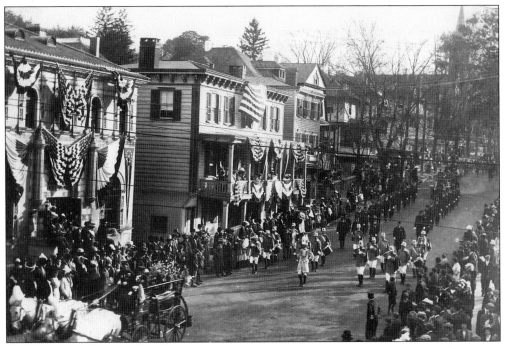

According to local accounts, the Hudson-Fulton Celebration was the most spectacular event the area ever experienced. The festivities lasted from September 25 to October 29, 1909, and included parades on the river and on the shore, parties, picnics, dances, and fireworks.

Eleven

Religious Life

The villages of Tarrytown and Sleepy Hollow have provided a home for a variety of religious denominations over the last three centuries. In the late 1600s there was only a single church serving the community, but by 1945 there were twenty-one religious institutions located within the two villages. While not all-inclusive, the selection presented here is representative of the deep religious commitment demonstrated by the people residing in the community.

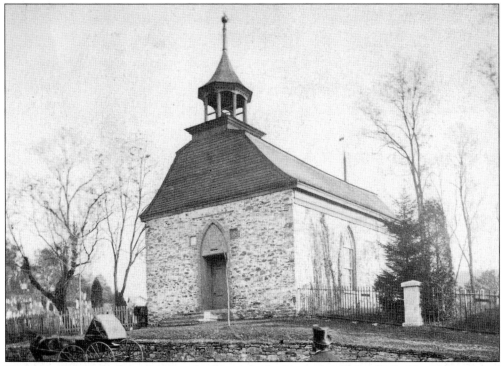

Frederick Philipse had the Old Dutch Church built close to his Upper Mills Manor House and the local congregation was formally organized in 1697. Originally called the "Christian Church of the Manor of Philipsburg," services were conducted in the Dutch language until after the American Revolution. The inscription on the church bell, cast in Holland in 1685, reads "Si Deus Pro Nobis, Quis Contra Nos" ("If God be for us, who can be against us?").

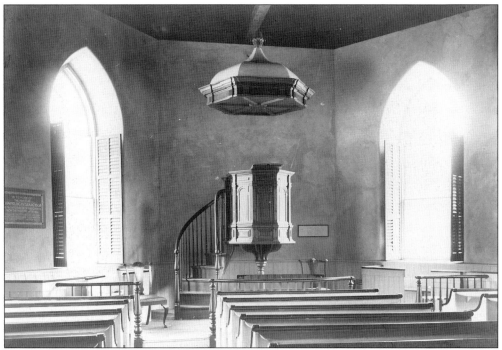

The present pulpit, a copy of the original made in Holland, was installed after the interior was renovated in 1837. The main door was moved to its present location and the windows were enlarged exposing the large yellow bricks from Holland.

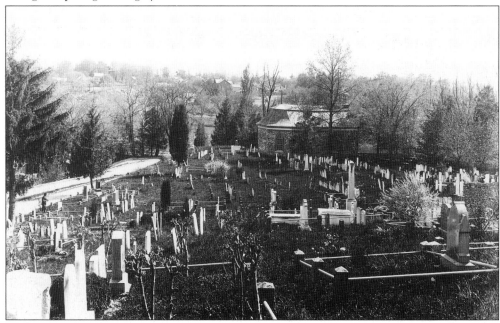

In the churchyard to the north, east, and south of the building, old sandstone gravestones, some bearing inscriptions in the Dutch language, are unique artistic testimonies to many of the early residents of the villages. Now a National Historic Landmark, the "Old Dutch Church" eventually became part of the Reformed Church in America and continues to be used today.

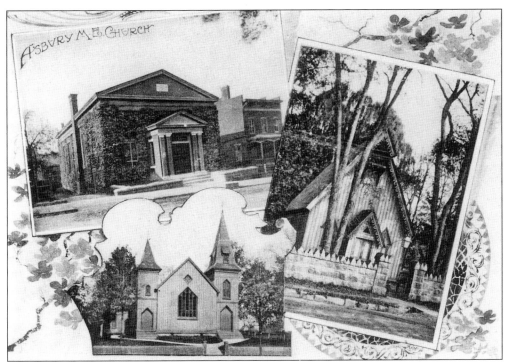

Organized in 1826, the Methodist Church of Tarrytown is the second oldest congregation in the community. When the present chapel was built in 1837, the name was changed to the Asbury Methodist Episcopal Church. The Beekman Avenue Methodist Protestant Church (center), was established in 1834. The Hope Chapel (1871) is at right.

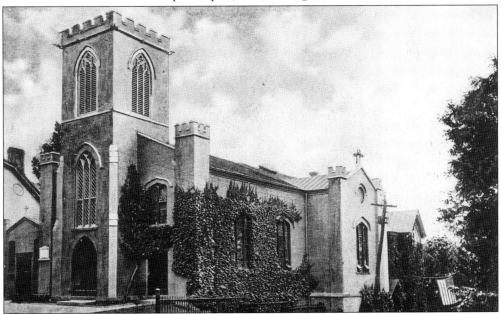

Located along Broadway in Tarrytown, the Christ Episcopal Church was in use by 1837. In 1859, under the service of Dr. William Creighton (rector 1837–65), the funeral of Washington Irving, a dedicated church warden and vestryman, was held in the church.

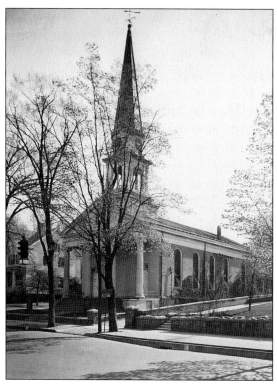

Finding it difficult to make the trip to the Old Dutch Church consistently, church members who lived on the south end of Tarrytown decided to construct the Second Reformed Church in 1837. Fourteen years later they formally became a separate congregation. Constructed in the Greek Revival style, the church building, located on Broadway near Central Avenue, has housed the village clock since the 1850s. Just after the turn of the century, in December 1902, the local Young Men's Christian Association was organized at the church by Robert Patteson and Rev. Dr. Arthur Mabon.

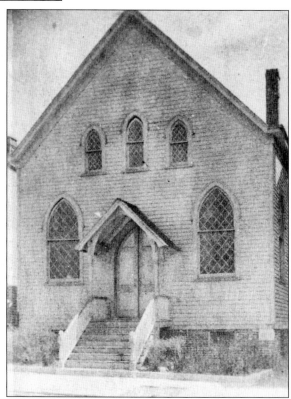

This photograph shows the original interior of the First Baptist Church of Tarrytown.

110

By the 1850s, the congregation of the Old Dutch Church had grown too large for the tiny church. Under the direction of the Reverend Abel Stewart, the First Reformed Church was constructed in a central location on North Broadway. As shown in the photograph, the original church, built in 1854, had a tall steeple facing Broadway.

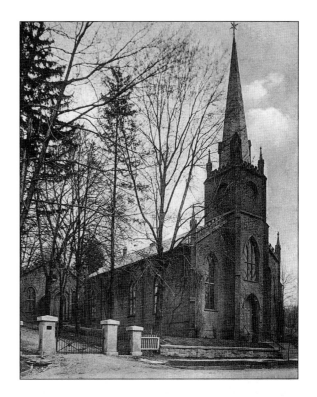

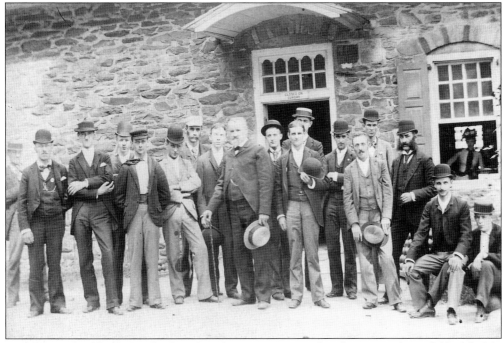

A Sunday school hall, called "The Chapel," was constructed at the First Reformed Church. Mr. N.H. Dumond's Bible class is pictured here outside the chapel in 1892.

Born in 1807 in the house of Governor De Witt Clinton, Amanda Foster eventually settled in Tarrytown. Both she and her second husband, Henry Foster, who she married in 1845, had deep religious commitment. In 1860 they organized the AME Zion Church in Tarrytown for members of the African-American community. The first meetings were held in Amanda's confectionery shop on Main Street. Constructed in 1864, the Foster Memorial African Methodist Episcopal Zion Church is a tribute to two unique and influential village residents.

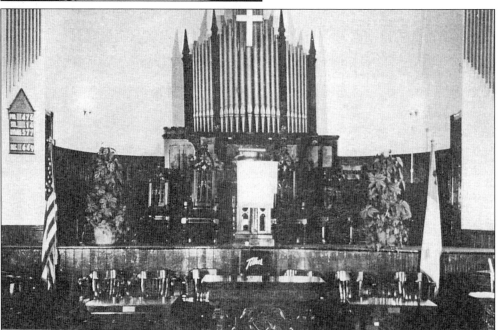

Organized in 1883, the Shiloh congregation was seeking a location for a house of worship. The following year, Henry T. Smith constructed an opera house on the southeast corner of Washington and Wildey Streets in Tarrytown. The congregation purchased the opera house in 1885 and renovated the interior for services. Now a designated landmark, the Shiloh Baptist Church is the second oldest church serving the African-American community in the villages.

The cornerstone was set for the First Baptist Church of the Tarrytowns on the corner of South Broadway and Elizabeth Street in 1876. Although the church was dedicated in 1881, the rectory was not built until 1896, when Mrs. William Rockefeller generously contributed toward its construction. Shown here in a photograph taken by E.M. Berrien in 1897, the large stone structure still serves the community.

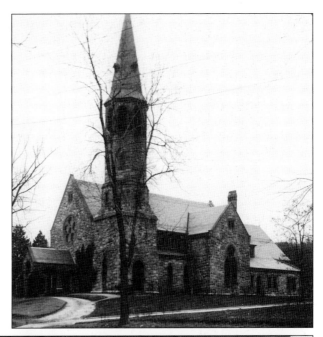

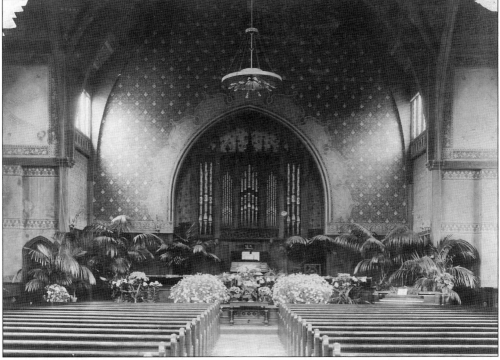

Early Jewish immigrants established the Hebrew Congregation of the Tarrytowns. Religious services were initially held in the homes of members, and for a short time Hyman Levy provided space above his shop to serve as "shul." It was clear, however, that the population was quickly outgrowing the locations selected for services. Under the leadership of Harry Benjamin, the first president of the congregation, the cornerstone was laid for the first Synagogue on Valley Street in 1904.

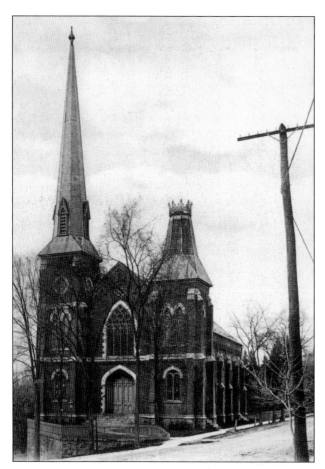

In the 1870s John Anderson donated land on the corner of Broadway and New Broadway for a new church. St. Paul's Methodist Episcopal Church was dedicated in 1878 and used until the 1930s. The brick parsonage associated with the church is still standing on the corner of New Broadway and Bedford Road. While the church is no longer standing, this location is still refereed to by some residents as "St. Paul's Hill."

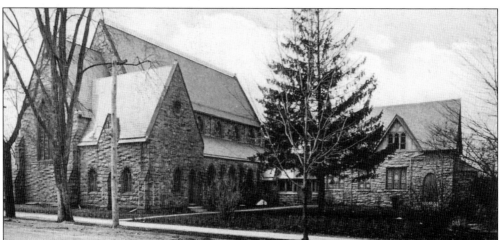

Originally a branch of Christ Episcopal Church, St. Mark's Chapel was constructed in 1861 on Beekman Avenue. After officially separating from Christ Church, the new congregation built St. Mark's Church on the corner of Broadway and College Avenue in 1868. The new church, sometimes called the Washington Irving Memorial Church, served the congregation until the 1950s.

In 1896 the Carmelites purchased an estate on South Broadway and Prospect for a new and growing parish. The parish constructed the French Gothic Church of the Transfiguration in 1897. The cross-shaped building was demolished in 1966 and replaced by a new church.

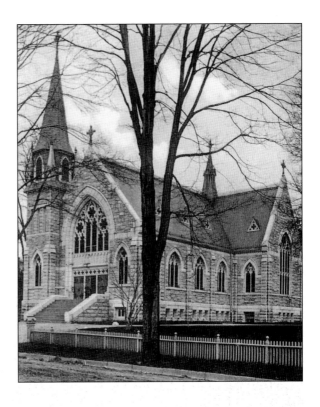

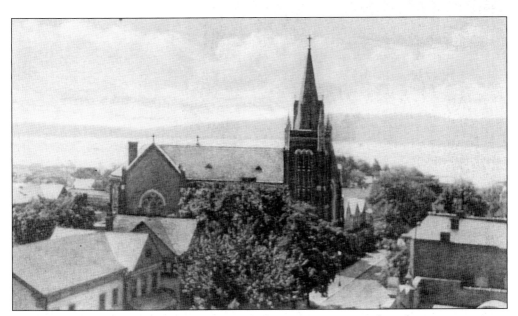

After the railroad was constructed along the Hudson, there was an influx of new immigrants to the villages. A new Catholic parish was needed to accommodate these individuals. Receiving money from local residents, including Washington Irving, Father Preston was able to purchase a parcel of land on Depeyster Street and build the first church. Shown on this postcard, the new and larger St. Teresa's, standing tall over the lower village, was dedicated January 31, 1909.

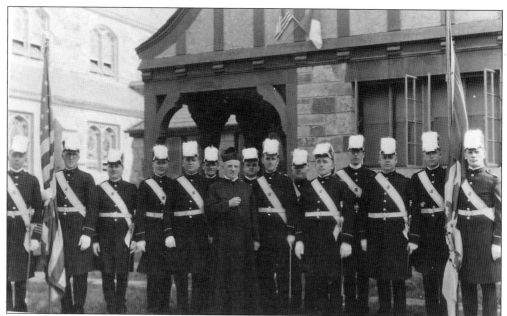

The color guard of the Knights of Columbus pose for a photograph. Shown here are, from left to right, Fred E. Peters, John McElroy, Joseph Pellagrino, Thomas McGirl, John Crowley, George Kirby, Reverend Donahue (pastor 1925–41), Mike Nicolasi, John Pollard, William Ward, Vincent Stronski, Charles Hofgartner, Joseph O'Neil, unknown, and Otto Specht.

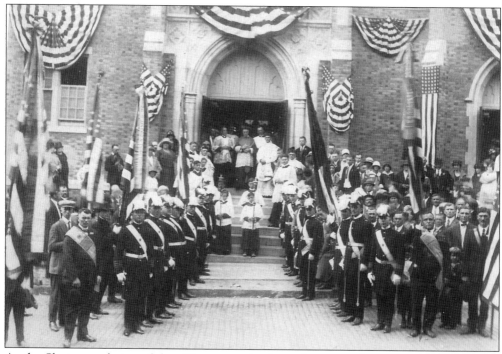

As the Slavic population of the villages grew in the early twentieth century, a petition for a new Catholic church was granted. Shown above is the dedication of Holy Cross Church on Cortlandt Street by Patrick Cardinal Hayes in September 1924.

Twelve

The People

Tarrytown and Sleepy Hollow have always been made up of a unique blend of individuals. From the simple shopkeepers to the wealthy estate owners, the people of the villages have always played a vital role in community life. Shown here are just a few of the many faces from the past that are present in our collective photograph album.

Following twenty-one years as a schooner captain on the Hudson River, Jacob Ackerman (left) became involved in local politics. After serving as the president of North Tarrytown from 1881 to 1883, Ackerman became the first keeper of the Tarrytown Lighthouse, saving nineteen lives before he retired in 1904. Benjamin Clapp (right) a well-known businessman and manufacturer of tin, sheet iron, and copper wares, owned a large hardware store on Cortlandt Street.

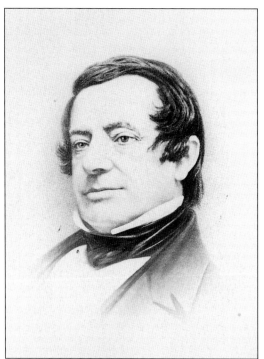

While visiting relatives in Tarrytown as a child, Washington Irving learned to love the local community. Written years later, his short story *The Legend of Sleepy Hollow* gave Tarrytown and Sleepy Hollow worldwide recognition. After he purchased a house in Tarrytown, he continued to write, travel, and accept political appointments, including a three-year assignment as the Ambassador to Spain, but always considered our community his home.

In 1835 Irving purchased the old Van Tassel farm known locally as Wolfert's Roost. Seated here on the porch of the house he extensively renovated and called Sunnyside, Irving had many famous visitors to his little cottage on the Hudson. He was very involved in village life and when he died in 1859, schoolchildren were excused from school for the day. Irving was buried in the Tarrytown Cemetery, now renamed Sleepy Hollow.

After the Village of Tarrytown was incorporated in 1870, Jacob Odell (1818–1887) a well-known village resident, was elected the first president (mayor). Odell owned and operated a large lumber yard at the foot of Main Street. In addition to wood, he also sold coal, lime, brick, cement, and plaster. In 1848 Jacob built a house on Grove Street which is now the headquarters of the Historical Society.

The Village of North Tarrytown established a post office in 1871. James M. Swift served as postmaster from 1885 to 1892 and from 1893 to 1899. North Tarrytown had a separate postmaster until the department became a branch of the Tarrytown Post Office in 1907.

A well-known community figure, Dr. Richard Coutant lived on the northeast corner of Main Street (Neperan Road) and Broadway. Coutant was the first chief of staff of the Tarrytown Hospital Association located at Wood Court in the 1890s.

After purchasing a sawmill on Cortlandt Street in 1850, Morgan Purdy (shown here in uniform) provided lumber and manufactured blinds and sash for over forty years. A businessman and public servant (tax assessor, board of education member), Purdy was one of the organizers of the North Tarrytown Fire Patrol. The major purpose of the patrol was to prevent looting during fires.

A dedicated physician, Dr. John Robertson served the community from a small office on Broadway near Beekman Avenue. Shown here with his predecessor's horse and buggy, Robertson's commitment to the community was honored when a small park at the intersection of Valley Street and Washington was established in his name. In the park a plaque states "His unselfish effort generosity and human understanding will ever inspire and guide us."

Mrs. Gertrude Van Cortlandt Beekman, photographed in 1905, was a descendant of two prominent local families. Until her death in 1913, she lived in a house on the corner of Beekman Avenue and Cortlandt Street. In her will Mrs. Beekman left several portraits of family members and early village residents to the Historical Society.

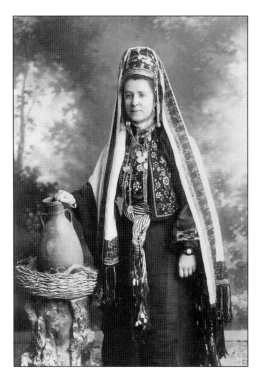

One of the twentieth-centuries greatest philanthropists, Helen Gould Shepard was a well-known figure in both business and society. Shown here on a trip to Jerusalem, the daughter of railroad tycoon Jay Gould spent much of her time at Lyndhurst, the family's country estate in Tarrytown. Locally, Helen's generosity provided much of the funds needed to establish Tarrytown's first hospital.

Helen Gould Shepard dedicated much of her time to helping and educating children. In Tarrytown, she founded Woody Crest, a home for crippled children, and the Lyndhurst Club, where young boys could learn carpentry. During the early twentieth century, Helen also operated the Lyndhurst Sewing School for young girls from local villages. Marie Jackson Plater (bottom right), shown here with the sewing class of 1911, donated her sewing class book to the Historical Society.

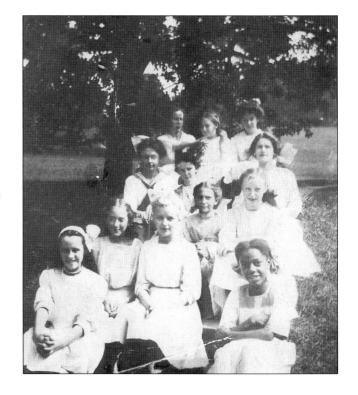

Elsie Janis was a much beloved singer and entertainer during the early twentieth century. Born Elsie Bierbower, she worked in Vaudeville and on Broadway before World War I. In 1916 Elsie purchased the Philipse Manor Upper Mills. During the war, she became known as the "Sweetheart of the AEF" (American Expeditionary Force) as she traveled through Europe entertaining the servicemen. After the war, Elsie and her mother restored the Manor house, where she lived until 1937.

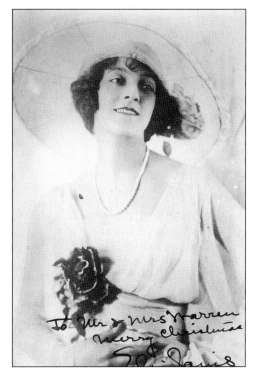

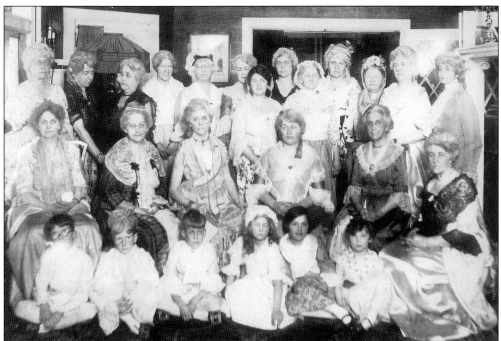

The Tarrytown Chapter of the Daughters of the American Revolution was established October 25, 1925. This photograph, taken by A.L. Trevillian in 1927, shows many of the Charter members dressed for a colonial tea. Seated in the second row (second and third from the left) are two of the founders, Mrs. Frederick L. Merriam and Mrs. Leslie V. Case (Organizing Chapter Regent).

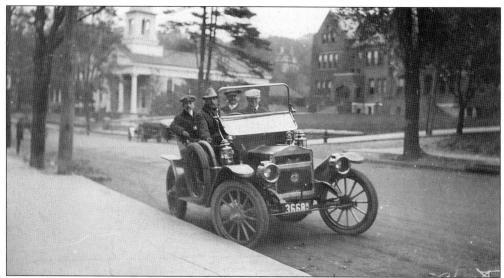

Shown in 1911, Judge Frank M. Millard (left) was counsel to the village of Tarrytown for fifteen years before he was hit by a Wolverine Express train and killed in 1914. His brother Charles (center left), also a judge, was elected supervisor of the town of Greenburgh. James Requa (center right) owned a grocery store on Main Street and served as Tarrytown Postmaster in 1906. Fred Russell (right) was well known for the pharmacy and soda fountain he co-owned on Main Street.

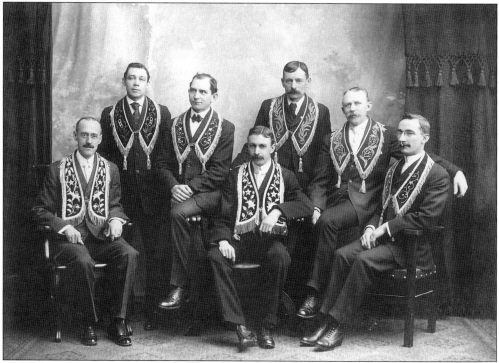

One of the many membership organizations that found a home in the villages, the Odd Fellows are shown here in 1908. The Odd Fellows' Hall was located at 86 Beekman Avenue.

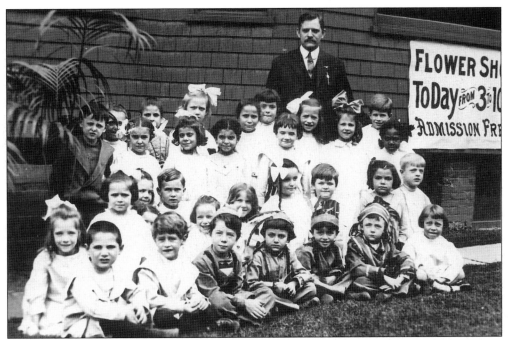

Shown here with a kindergarten class at the Lyceum building, Leslie V. Case was teaching in the Tarrytown schools by 1900. Five years later he was appointed principal at Washington Irving High School, and he later went on to serve as the first superintendent of the Tarrytown schools for thirty years. An avid collector and scientist, Case left a wonderful collection of materials to the Historical Society.

A long-time resident of John Street, Mr. Clarence Jackson (left) was the superintendent of the Sunday school at the Shiloh Baptist Church for many years.

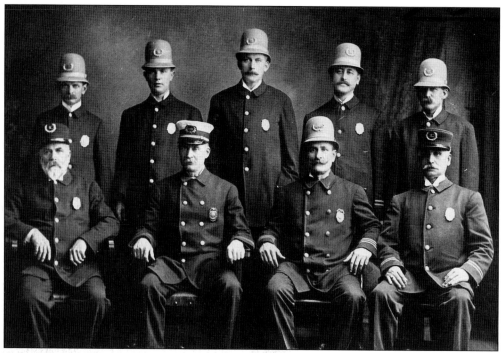

A formal police department was organized in Tarrytown in 1887. This photograph from 1912 shows, from left to right: (front row) William Humphreys, Chief William J. Bowles, Sgt. Alden Delanoy, and Oscar Purdy; (back row) Charles Briggs, Edward Martin, Patrick Ryan, James Burns, and Charles Schneider.

The president of Standard Oil, John Davison Rockefeller Sr., shown here with his grandson, came to the villages in 1893. One of the country's leading philanthropists, Rockefeller soon became involved in a number of local organizations.

Like his father, John D. Rockefeller Jr. participated in a variety of activities in both Tarrytown and Sleepy Hollow. A leading force in the nationwide preservation movement, locally he supported the creation of the Sleepy Hollow Restorations, later renamed Historic Hudson Valley, and was a generous supporter of the Historical Society. He was also involved in the reorganization of the school system and the construction of the Van Tassel Apartments on Beekman Avenue.

In the latter half of the twentieth century, the grandsons of John Sr. have each had an impact upon the local community. Shown above are, from left to right, David, Nelson (governor of New York 1959–73 and vice president of the United States 1974–76), Winthrop, Laurance, and John D. Rockefeller III.

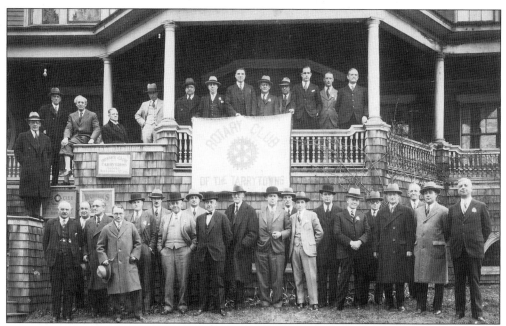

One of several civic-minded organizations in the villages, the Rotary Club was established in 1921. The first of the national service clubs to set up a branch in the villages, the Rotary Club helped establish the Chamber of Commerce and Westchester Community College.

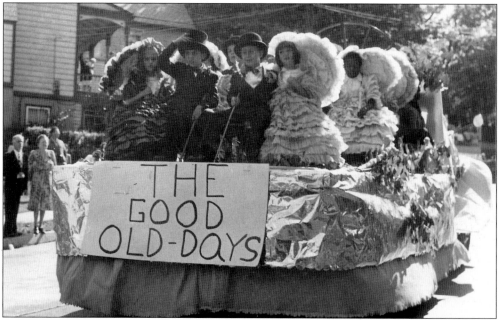

The American Association for the United Nations picked the contiguous villages of Tarrytown and North Tarrytown as a typical American community to celebrate and promote the United Nations during UN Week September 14–20, 1947. Thousands of out-of-town visitors poured into the Tarrytowns during the week-long round of festivities and the two-hour parade of floats and bands. Our community was chosen because it was felt that the villages symbolized the idea that diverse people can live together in harmony.